PRINT YOUR OWN PICTURES

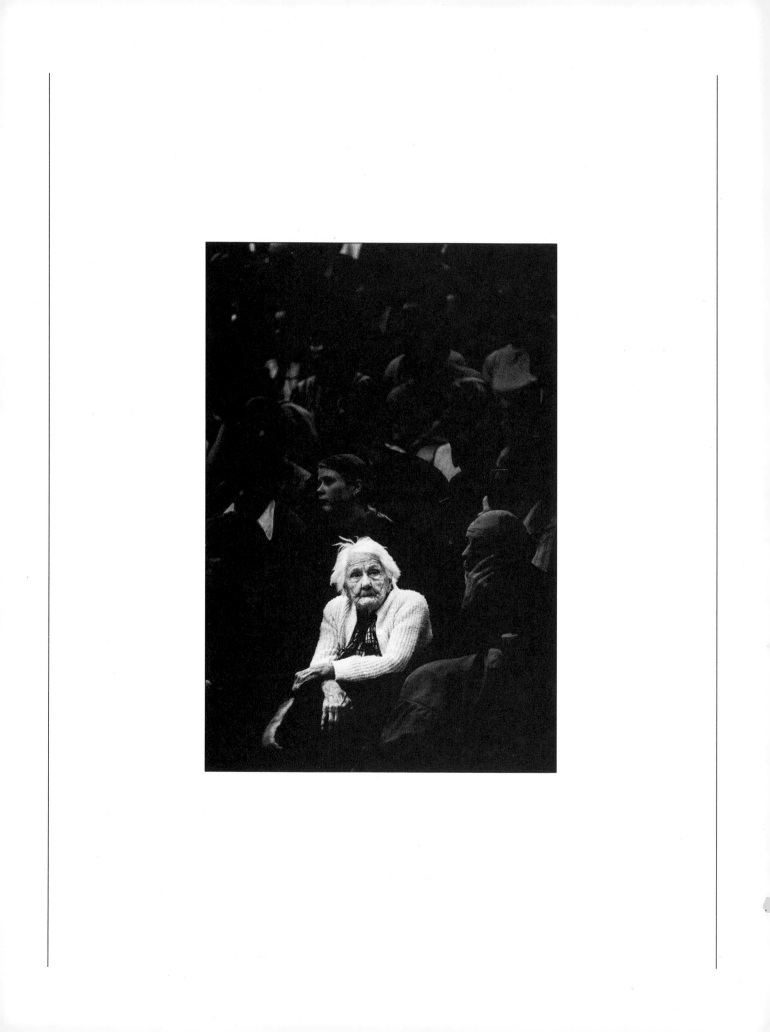

PRINT YOUR OWN PICTURES

Published by Time-Life Books in association with Kodak

PRINT YOUR OWN PICTURES

Created and designed by Mitchell Beazley International
in association with Kodak and TIME-LIFE BOOKS

Editor-in-Chief
Jack Tresidder

Series Editor
Robert Saxton

Art Editors
Mel Petersen
Mike Brown

Editors
Louise Earwaker
Richard Platt
Carolyn Ryden

Designers
Marnie Searchwell
Stewart Moore

Picture Researchers
Veneta Bullen
Jackum Brown

Editorial Assistant
Margaret Little

Production
Peter Phillips
Jean Rigby

Written for Kodak by Paul Bennett

Coordinating Editors for Kodak
John Fish
Kenneth Oberg
Jacalyn Salitan

Consulting Editor for Time-Life Books
Thomas Dickey

Published in the United States
and Canada by TIME-LIFE BOOKS

President
Reginald K. Brack Jr.

Editor
George Constable

The KODAK Library of Creative Photography
© Kodak Limited All rights reserved

© Kodak Limited, Mitchell Beazley Publishers,
Salvat Editores, S.A., 1984

Library of Congress catalog card number 127 1394
ISBN 0-86706-231-2
LSB 73 20L 11
ISBN 0-86706-230-4 (retail)

Contents

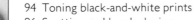

THE FINISHED PICTURE

For some photographers, pressing the shutter release marks the end of the photographic process. But for others, the moment of exposure is just the beginning. Master photographer Ansel Adams compares a negative to a musical score. "The print," he explains, "is the performance."

Just as musicians interpret a piece of music each time they play it, so too you can use the printing process to control or change the appearance of your pictures. For example, the delicate pastel portrait opposite is not a slavish copy of the original transparency. In the darkroom, the photographer took the opportunity to print the slide in several different ways, adjusting the hues, lightening and darkening the print overall, and then moderating the tones of individual areas of the picture. Thus, the image that appears here is the best of several pictures – the result of the photographer putting as much care and attention into printing the photograph as she did into taking it.

The pages that follow show further examples of such darkroom creativity. Despite the apparent complexity of some of the images, none was particularly difficult to achieve, and all are within the scope of a photographer working in a makeshift home darkroom with basic equipment.

A study in pastel tones illustrates how careful printing can enhance a picture. To emphasize the subject's features in an attractive oval frame, the photographer vignetted the print: that is, she used a piece of cardboard on a wire to mark the center of the image during exposure. The overexposed surround thus appears white.

6

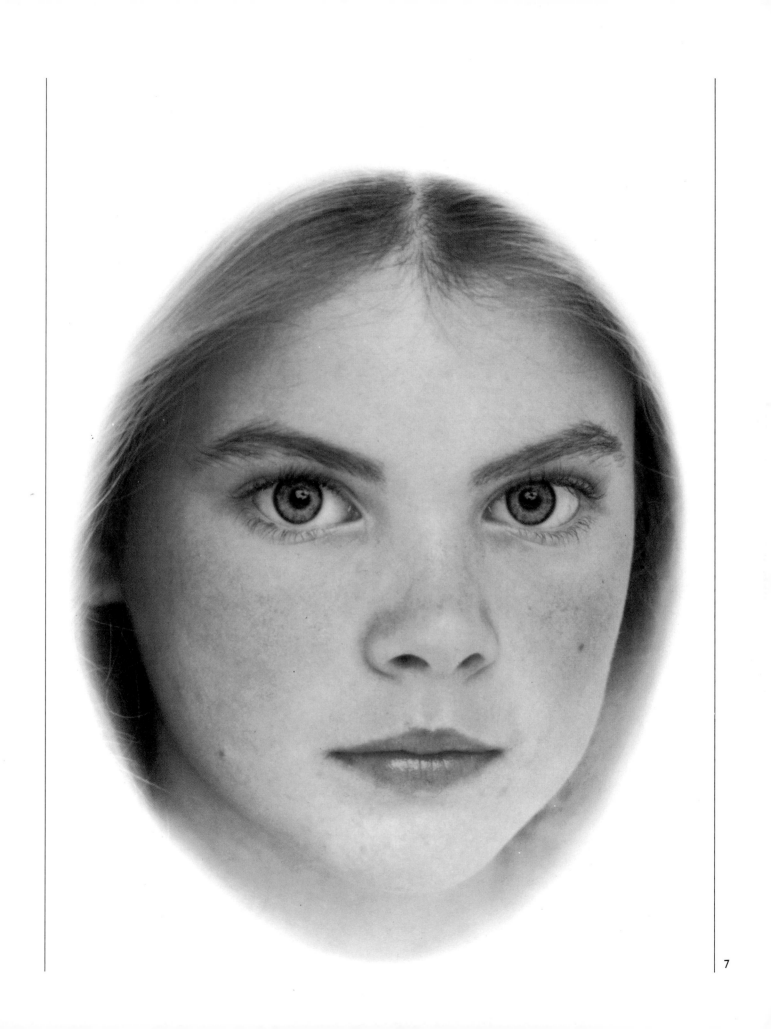

Perfect color fidelity gives
appetizing freshness to a still-life.
In his own darkroom, the photographer
had complete control over the colors,
and could add and subtract filters in
the enlarger to obtain an absolutely
lifelike result.

A hand-tinted print achieves
its effect by strong contrasts within
a limited range of hues. Starting
with a black-and-white negative, the
photographer printed the picture lighter
than normal to provide a neutral tone
for the watercolor finish.

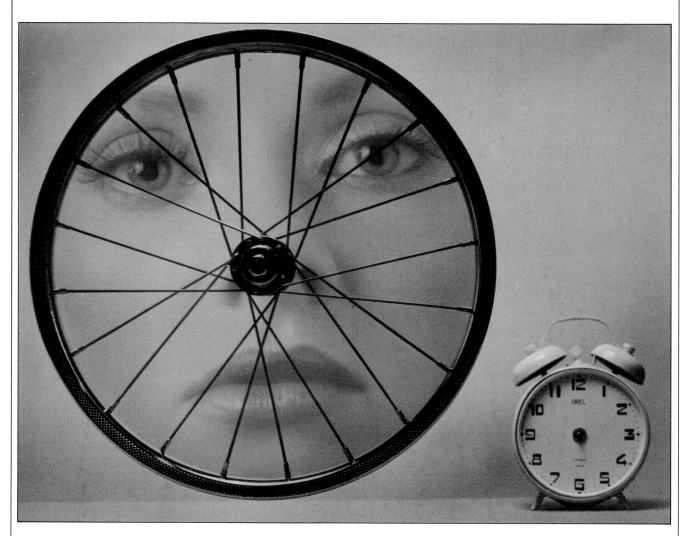

A surreal composition combines
the elements of time and travel with a
woman's face. The photographer
saw the potential for creatively adapting
a portrait she had taken. She set up
and photographed a still-life of a
wheel and a handless clock, and in the
darkroom printed the negative of this
on the same paper as a negative of the
portrait. During printing, she masked
over those parts of the face that fell
outside the wheel by using a piece of
cardboard with a hole cut in it.

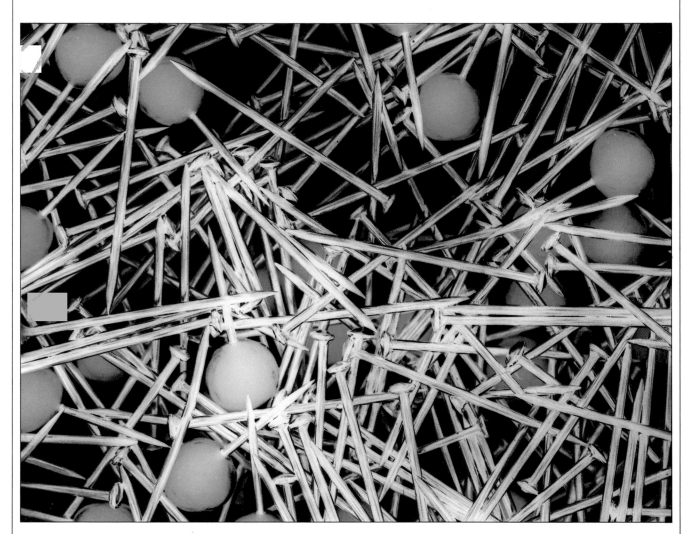

An abstract image results from placing assorted pins in the negative carrier of an enlarger and then making an exposure on color printing paper. Some of the pins were capped with red plastic, and the paper reversed their hues to green or blue. Repeated experiments with color filtration in the filter drawer of the enlarger produced the beautiful effect. This type of picture, made by placing objects – rather than a negative – in the beam of the enlarger, is called a photogram.

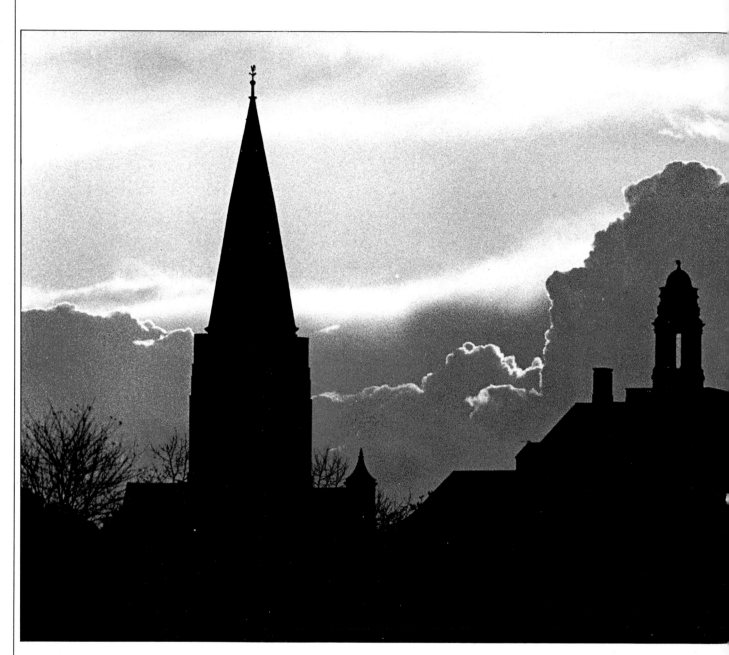

A church spire soars into the sky as storm clouds disperse above it. Starting with a straightforward negative, the photographer deliberately printed the image darker than usual to increase the drama of the sky and to render the buildings as silhouettes. After processing, he placed the print in sepia toner to turn the clouds a warm brown.

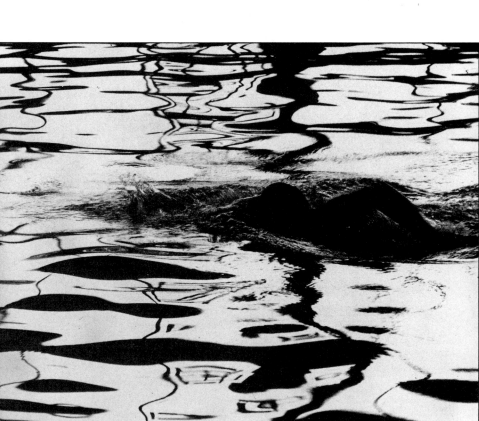

*A **swimmer** slices through the water, breaking up regular reflections into elegant swirling lines. The scene had naturally high contrasts of black and white. But printing onto high-contrast paper increased this separation of tones still further, so that the picture turned into a pattern of abstract liquid shapes.*

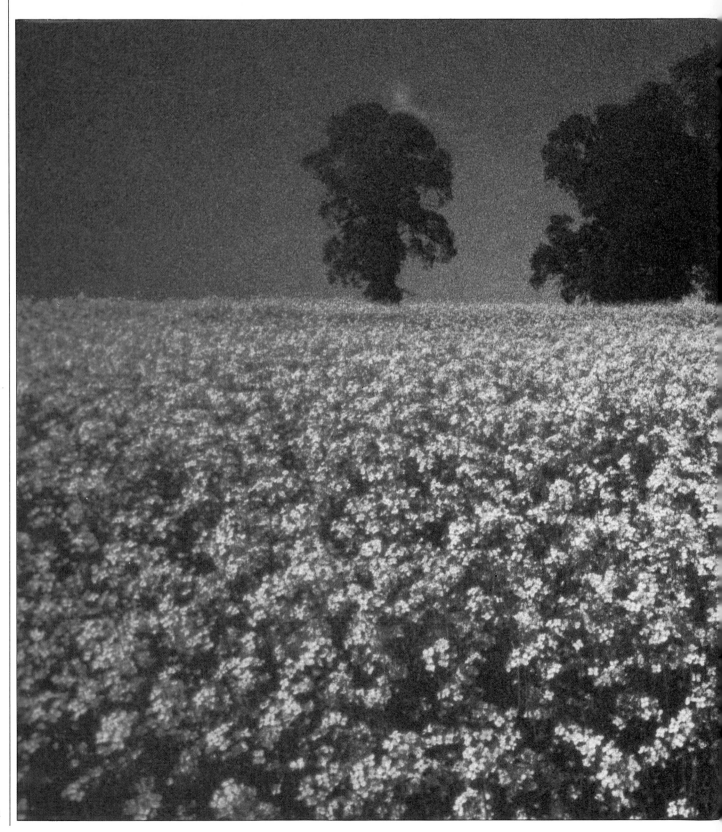

A broad landscape comes alive with rich color. In the original slide, the flowers were pale yellow and the sky a weak blue. By reducing exposure during printing, the photographer transformed the scene with dense saturated colors.

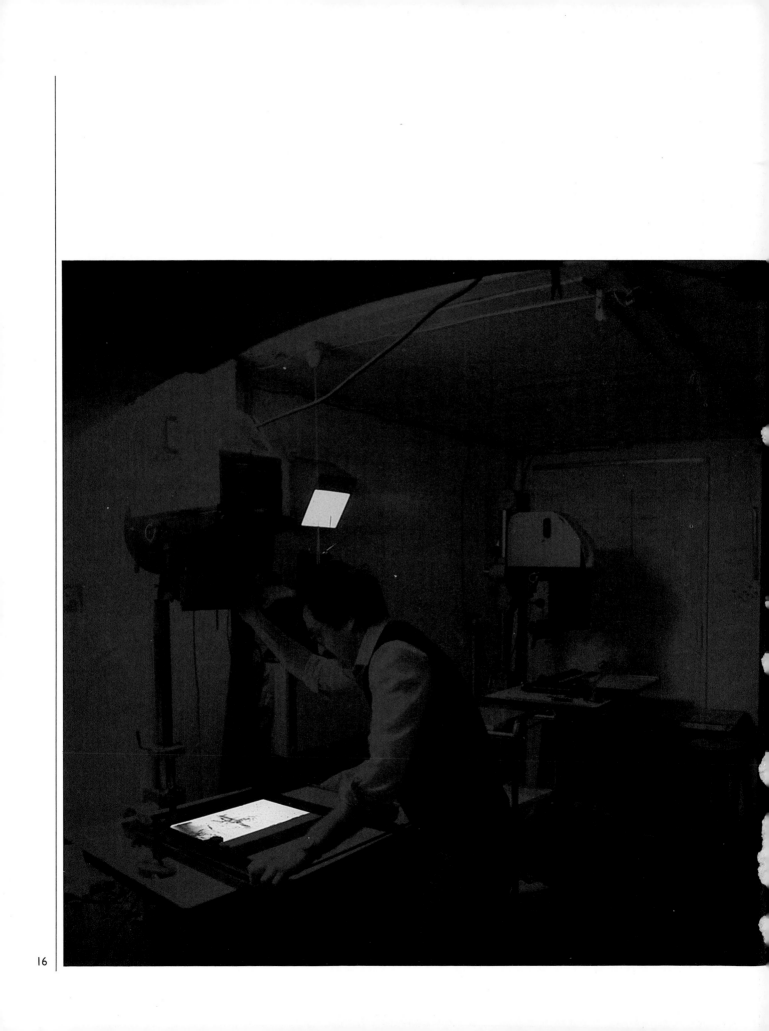

THE HOME DARKROOM

The marvelous advantage of home processing is that you have complete control over the results. You can make your images as small or large, light or dark as you wish. And your darkroom work will also help you to understand more about photography itself, enabling you to improve composition, exposure and many other aspects of your picture-taking skills.

To begin with, you may decide to set up a darkroom just for black-and-white processing and printing. The basic procedures are relatively simple and will stand you in good stead if you later go on to making color pictures. However, with today's equipment and materials, there is no reason why you should not start with color processing if that is your main interest. Moreover, virtually all the equipment needed for color printing can be used for both negatives and slides; you need only buy different chemicals and papers for processing each film type.

Printing your best pictures at home may be a little more costly than having a commercial laboratory print every frame on your roll. However, in a home darkroom you can give your prints individual attention, bringing out subtle qualities that mass-produced printing conceals. The cost of making such hand-crafted prints at home is a small fraction of what a commercial laboratory would charge you for the same service.

A dry basement, with plenty of space for equipment, makes an ideal darkroom. Here, a black-and-white print is made on an enlarger. The red and yellow safelighting does not affect black-and-white printing paper yet provides a good level of light to work by.

17

From film to print

The sequence of illustrations and diagrams at right shows that all routes from film to finished print begin from the same point – processing in a light-tight developing tank. Whether you are working with black-and-white, color print or color slide film, you always need to load exposed film in darkness into a tank of this kind and then pour in temperature-controlled solutions at timed intervals to make the image visible and stable. Washing and drying complete this stage, which yields a negative of the black-and-white or color print film, or a transparency of the slide film. Color processing usually requires more solutions than black-and-white processing, and transparencies require more processing stages than color negatives. But no one type of film is seriously more difficult to process than any other.

Variations in handling the different film types become more evident after processing, when you start printmaking. An enlarger, by shining light through the negative or slide, transfers an image to light-sensitive paper, which in turn needs processing to produce the final print.

Part of the enjoyment of black-and-white printing (top row of diagrams) is that you can work under a safelight that lets you see what you are doing. You need only three solutions, set out in photographic processing trays. Slid first into a tray containing developer, the printing paper gradually begins to show a visible image. After a stop bath and fixer bath, the print is ready for washing. And for all three solutions temperature control is not as critical as it is in color printing.

Printing in color is a little more exacting and costly than in black-and-white. You must judge color filtration as well as exposure, and you need to expose the print in near or total darkness. The actual developing process need not take place in the dark; you can load the paper into a light-tight drum and process the print in ordinary room light.

However, because the color print is locked inside the drum, you cannot watch the image appearing on the paper's surface, and you must keep track of the development process some other way. You do this by precisely controlling the time that each solution remains in the drum, by maintaining the solutions at a constant temperature and by consistent agitation of the drum throughout. This necessary extra control means that color printing demands a more methodical approach than black-and-white.

A simpler but somewhat more expensive color printing process uses Kodak Ektaflex PCT products. With a special Ektaflex printmaker, you can process pictures from either slides or negatives. You need only one solution, and processing takes place at room temperature.

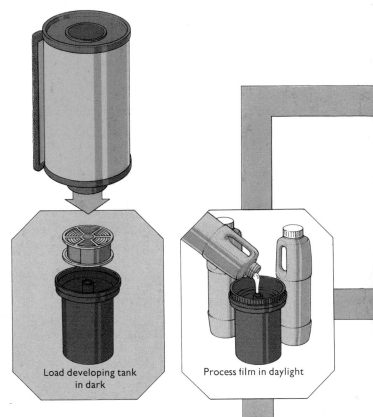

Load developing tank in dark

Process film in daylight

Making prints

The simplified chart here shows the basic steps from film to print, working with black-and-white or color print film or transparencies. The black-and-white negative (top row) needs only white light from the enlarger to print an image on paper, which is then immersed in turn in three different solutions. More technique is involved when you are beaming light through a transparency (bottom row) or a color negative (middle row) because of the need for color filtration. You can process the prints from both types of color film in trays, but the procedure is easier in drums as shown here. The solutions poured into the drum have to be at just the right temperature, and controlled agitation is necessary. Ektaflex PCT products provide an easier and quicker route.

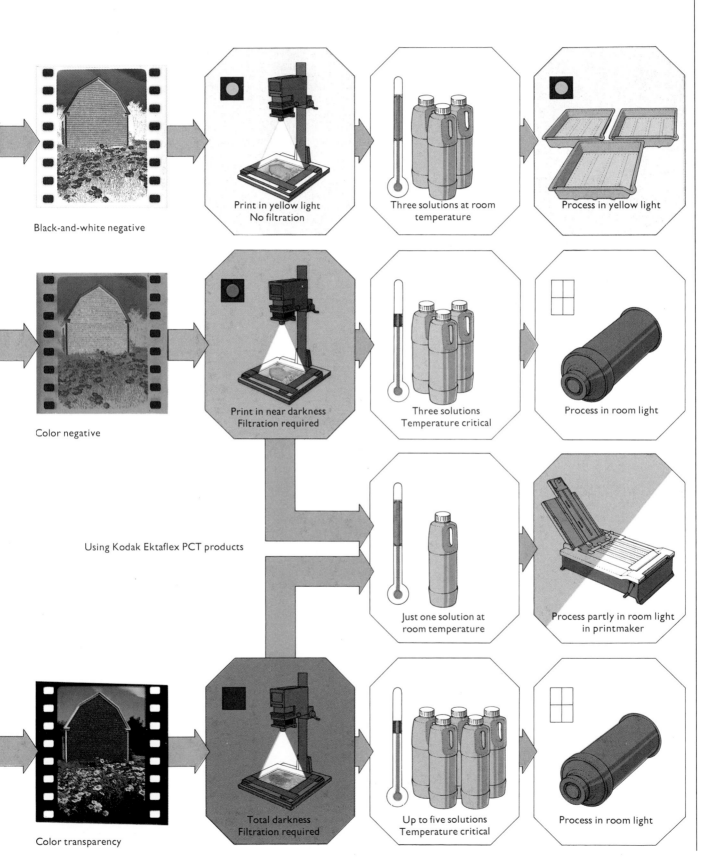

Black-and-white negative

Print in yellow light
No filtration

Three solutions at room
temperature

Process in yellow light

Color negative

Print in near darkness
Filtration required

Three solutions
Temperature critical

Process in room light

Using Kodak Ektaflex PCT products

Just one solution at
room temperature

Process partly in room light
in printmaker

Color transparency

Total darkness
Filtration required

Up to five solutions
Temperature critical

Process in room light

The improvised darkroom

To start home processing you will not need a special room – just an area that you can make completely dark and that provides enough space to work in. A bathroom, as shown below, or a kitchen makes a convenient temporary darkroom because there is running water to wash processed film and prints. But a closet, such as the one on the opposite page, will do. You can take film or color prints to develop and wash in another room once you have loaded them into a light-tight developing tank or processing drum in the dark. And although you must deve-

lop black-and-white prints in the darkroom itself, you can put the developed prints in a plastic bucket or bowl of water and wash them under running water later.

Electricity is needed for an enlarger and a safelight – a special light that does not affect printing paper. You also need a flat, stable surface for equipment. To prevent damage from spills, keep trays of chemical solutions separate from the printing area. If space is limited, raise the enlarger above the trays or put up a wood or plastic splash guard.

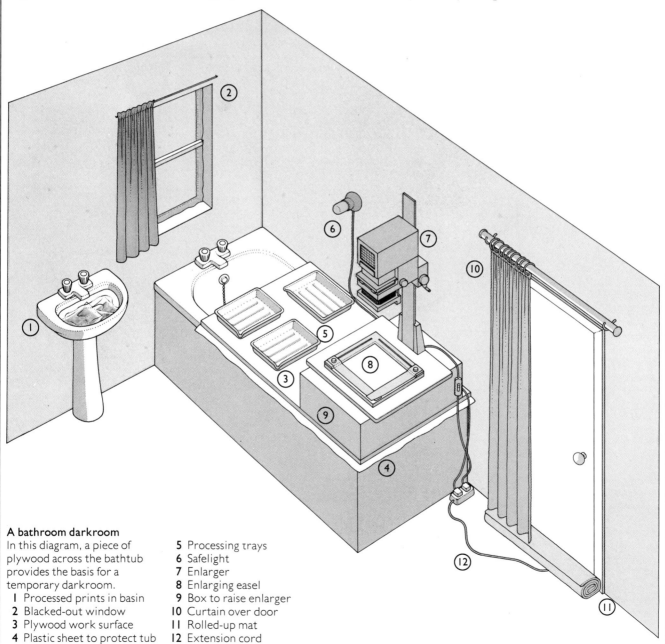

A bathroom darkroom
In this diagram, a piece of plywood across the bathtub provides the basis for a temporary darkroom.

1 Processed prints in basin
2 Blacked-out window
3 Plywood work surface
4 Plastic sheet to protect tub
5 Processing trays
6 Safelight
7 Enlarger
8 Enlarging easel
9 Box to raise enlarger
10 Curtain over door
11 Rolled-up mat
12 Extension cord

Complete darkness is essential; any chink of light will fog undeveloped film or paper. The box at right shows a good way to black out windows. To block light from the door, hang a curtain over the inside, and place a rolled-up mat against the bottom. To test whether the room is lighttight, place a coin on a piece of printing paper and, after five minutes, process the paper; if the coin leaves a circular mark, you have a light leak. If the room has a fluorescent light, wait at least 10 minutes after switching it off before handling photographic film or paper.

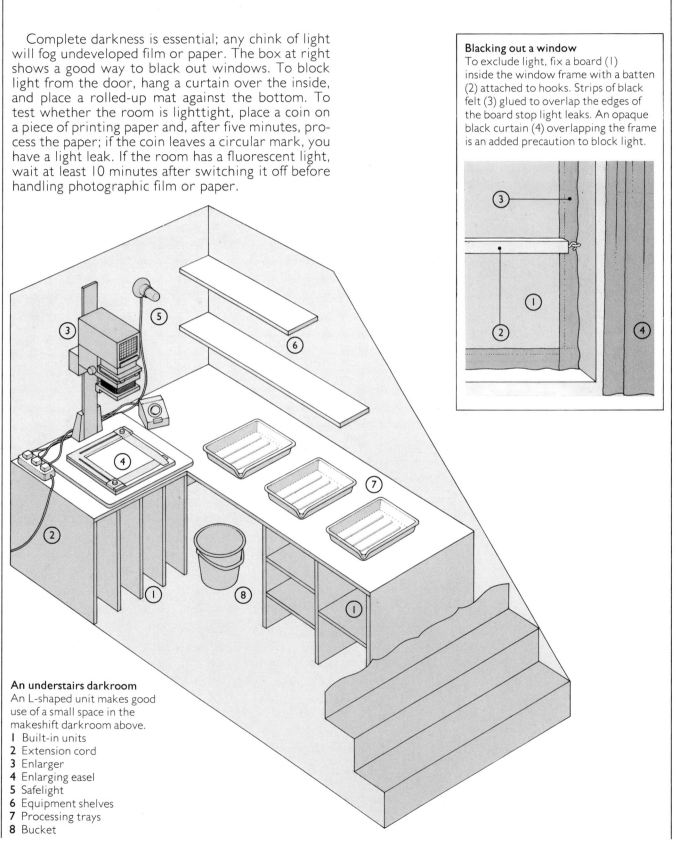

Blacking out a window
To exclude light, fix a board (1) inside the window frame with a batten (2) attached to hooks. Strips of black felt (3) glued to overlap the edges of the board stop light leaks. An opaque black curtain (4) overlapping the frame is an added precaution to block light.

An understairs darkroom
An L-shaped unit makes good use of a small space in the makeshift darkroom above.
1 Built-in units
2 Extension cord
3 Enlarger
4 Enlarging easel
5 Safelight
6 Equipment shelves
7 Processing trays
8 Bucket

The permanent darkroom

A permanent darkroom, such as the one dia-grammed at right, allows you to work whenever you like without spending a lot of time setting things up. You can convert a spare bedroom, a loft or an attic, but these rooms may not be spacious enough to work in comfortably. The ideal place is a dry base-ment. Many basements have electrical outlets and cold water connections; and basements are rela-tively easy and inexpensive to adapt for darkroom use. Blacking out a basement, for example, is usually simple because the windows tend to be small.

Design your darkroom around the processes you will carry out, minimizing the need to walk, while keeping a clear separation between the wet area (where chemicals are used) and the dry area. The best layout has a wet bench on one side of the room and a dry bench on the other, but if space does not allow this, place the benches end to end with a splash guard between them. Use ready-made kitchen units unless you want to build the work sur-faces yourself. You should protect your wet bench against chemicals with a covering of plastic laminate. A ready-made darkroom sink designed to accommo-date trays and wash tanks is ideal. However, you can adapt a kitchen sink or make your own photo-graphic sink out of wood, waterproofing the bowl by lining it with fiberglass cloth and then coating it with plastic resin.

Black out any windows permanently with wood or fiberboard, making sure that all the cracks are sealed with filler. You can make doors lighttight by fixing baffles to the floor and frame and by covering the gap on the hinge side with a strip of flexible material that will not impede opening or closing. A large darkroom may need more than one safelight. Light-colored walls help reflect safelighting, but you should paint the wall area around the enlarger mat-black to cut out reflections from the enlarger head. If the room has a light with a pull switch, run a length of heavy string, above head height, from the switch to the other side of the room, so that you can turn the light on or off easily with wet or dry hands from wherever you are standing.

To streamline darkroom work you need various fittings and fixtures. Mount shelves above each bench for storing materials and equipment. A bulletin board – perhaps covering a blacked-out window, as in the darkroom shown at right – is useful to display manufacturers' instructions. You should also have a darkroom clock – preferably a large one – and a towel holder near the sink.

Do not smoke in the darkroom, and keep it clean at all times. To make sure that nobody blunders in on you and lets in light, put a sign on the outside of the door whenever you are working.

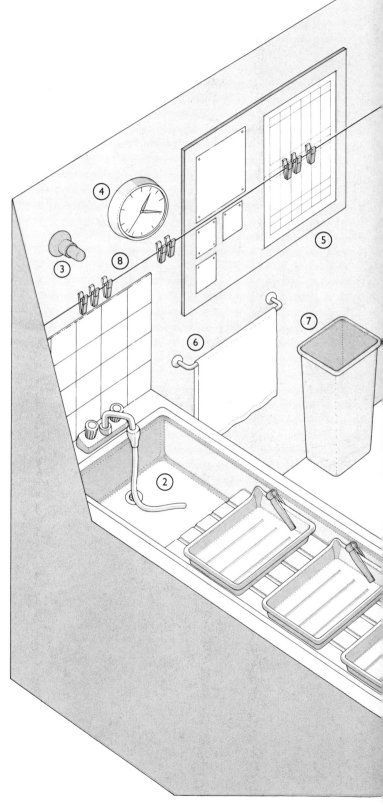

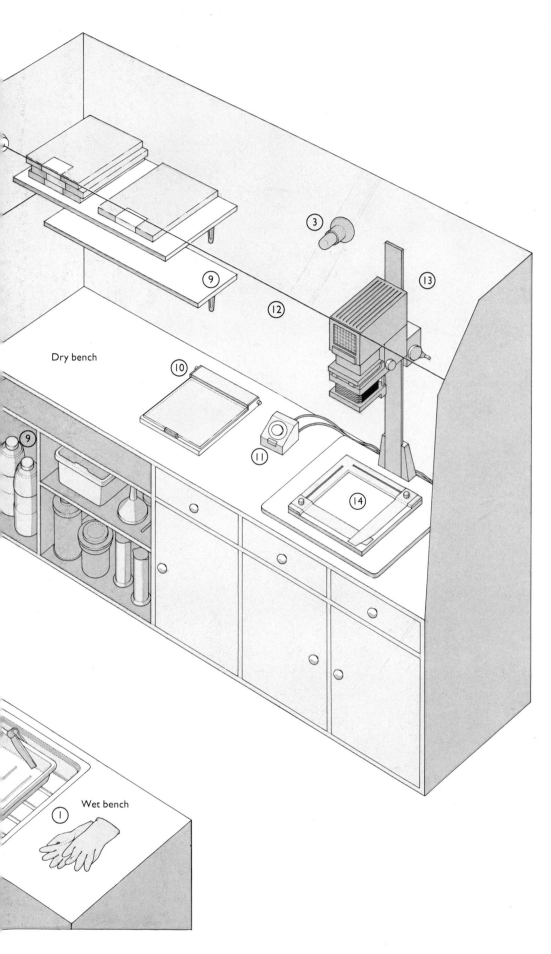

Dry bench

Wet bench

A basement darkroom
A setup such as the one shown at left gives you the best chance to process and print pictures efficiently and creatively without your interfering in normal household activities – and vice versa. You can expect to find at least the following items in any well-equipped home darkroom. Other, optional items will be shown and discussed later in the book.

1 Processing trays
2 Photographic sink
3 Safelights
4 Clock
5 Bulletin board (covering permanently blacked-out window)
6 Towel on holder
7 Trash can
8 Clothesline with clips for drying prints
9 Shelves for equipment and materials
10 Frame for making contact prints
11 Timer
12 Overhead string attached to pull light switch
13 Enlarger
14 Enlarging easel

Black-and-white darkroom equipment

A major piece of equipment used to print pictures is an enlarger, but you must also buy a number of smaller items. To develop film, you will need a developing tank and the reel that goes with it. Once you have wound your film onto the reel in darkness, and placed both inside the tank, you can turn on the lights and begin processing in normal room light.

To get consistent results, you must be able to measure three things accurately: time, temperature and volume. Any clock that has a sweep second hand will be precise enough to measure time, but to measure the other two variables you should buy a special photographic thermometer and at least two graduated cylinders.

To make prints, you can use the same thermometer and graduates as for processing film. You can also use the same clock, but more efficient is a timer that can be wired to the enlarger to automatically shut off the lamp after exposure. In addition you need three trays in which to develop and stabilize the paper prints and two pairs of tongs to transfer the chemical-soaked paper from one tray to the next. A safelight is also essential.

The enlarger magnifies your negative to the size of the print you choose to make, much as a movie projector throws an enlarged image onto a screen. Although an enlarger is not cheap, it is a one-time investment, and you can use the same enlarger to print both black-and-white and color prints.

Finally, you will need an enlarging easel, often called a masking frame. This holds the photographic paper flat and positions it on the enlarger baseboard. Adjustable blades enable you to print pictures with borders of variable width.

Film developing equipment

Choose a developing tank and reel that match the size of the film you use. Some reels are adjustable, so that you can use them to develop both 35mm film and rollfilm. Buy two graduates, a large one for mixing chemicals and a small one for measuring concentrated solutions. A good choice of size is 32 and 8fl oz (1,000 and 250ml). Many pieces of equipment you can find around the house. For example, although special film clips are available to hang up film while it dries, clothespins will do the job almost as well. A bottle opener is useful for opening 35mm film cassettes. However, household thermometers are not precise enough, so buy a darkroom thermometer. Rubber gloves should be worn whenever you handle undiluted chemicals.

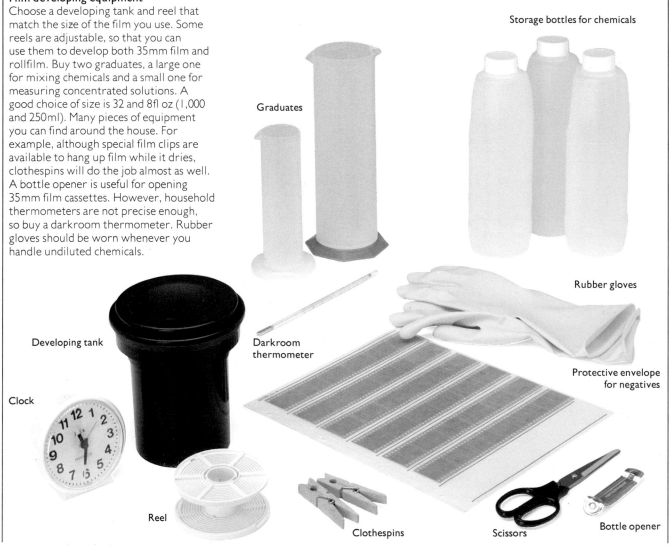

Storage bottles for chemicals

Graduates

Rubber gloves

Developing tank

Darkroom thermometer

Protective envelope for negatives

Clock

Reel

Clothespins

Scissors

Bottle opener

Printing equipment

When buying printing equipment, always make sure that the easel and trays will accommodate the largest size of print you are likely to make. The enlarger itself should be capable of making a print 50 percent bigger than this, because you may want to enlarge just the central portion of a negative. A wide range of safelights is available from photo dealers. Be sure to use the appropriate filter recommended by the printing paper manufacturers.

Enlarger

Trays

Timer

Clothespins

Print tongs

Brush and compressed air
for cleaning negatives

Enlarging easel

Safelights

Washing and drying prints

After processing, you must wash each print in running water for four or five minutes. An automatic tray siphon converts any print tray into an efficient print washer. If your darkroom does not have any running water, wash prints in a deep sink elsewhere. A length of hose attached to the faucet and a plastic pipe in the outlet will ensure a continuous flow of water, as shown in the diagram below.

You can dry most types of printing paper by laying the prints out flat on an absorbent surface, such as a clean towel or a blotter; by hanging the pictures on a line; or, more quickly, by using a hair dryer.

Graduates with
darkroom thermometer

Funnel

Storage bottles for chemicals

Color darkroom equipment

The equipment used to develop color materials in a home darkroom differs only slightly from that used for black-and-white work. Because most color processes involve more stages, you need extra bottles and graduates to store chemicals and to measure and hold made-up solutions. You also need a temperature-control bath that will hold enough warm water to keep the solutions in graduates at the specified temperature; a large bowl will do. Temperatures are higher and more critical than in black-and-white processing, so the third requirement is an accurate high-temperature thermometer.

The key item in color printmaking is the enlarger, which you should use with a voltage regulator because even small fluctuations in voltage can cause color changes in the print. Most enlargers have a filter drawer, as shown in the example on the opposite page, for holding special filters that modify the color of the enlarger light source to produce the correct color balance.

The only other important item of additional equipment needed for a color darkroom is a processing drum, which is relatively inexpensive to buy. Although you can process color prints in trays, a processing drum is more convenient because it allows you to carry out most of the process in normal light.

For extra speed and simplicity of operation, consider investing in a rapid-access print processing system such as that described in the box on the opposite page.

Film developing equipment (below)
You can process color films in the same daylight developing tanks that are used for black-and-white developing. Color chemicals can be harmful to sensitive skin, so be sure to wear rubber gloves when handling them.

To time the developing process, an ordinary clock with a second hand is adequate. The thermometer should be capable of accurately measuring temperatures in the range of 74 F to 105 F (23–41 C).

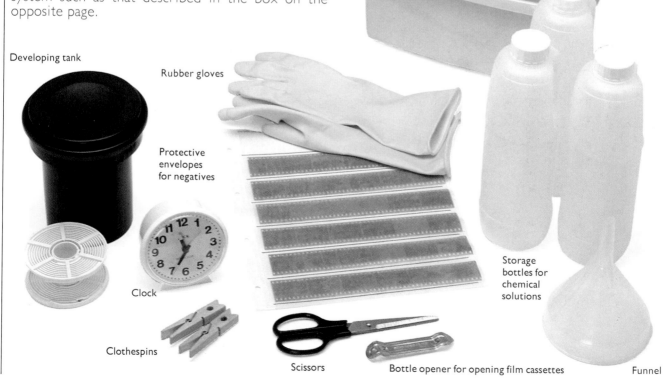

Bowl, graduates and high-temperature thermometer

Developing tank

Rubber gloves

Protective envelopes for negatives

Clock

Storage bottles for chemical solutions

Clothespins

Scissors

Bottle opener for opening film cassettes

Funnel

Printing equipment (below)
Color printing filters come in three hues – yellow, cyan and magenta. You need a full set (usually several filters per hue, each of a different density), plus an ultraviolet and an infrared heat filter. If you plan to make color prints in any quantity, you may prefer to buy an enlarger fitted with a color head. This device, which contains up to three adjustable color filters, greatly simplifies filtration.

Other essential items for color printing include a processing drum, a bowl (used as a temperature-control bath), a bucket (for soaking the loaded drum in warm water before processing) and a timer wired to the enlarger to time exposures.

Kodak Ektaflex PCT products
Rapid-access color printing products dispense with the need for storage bottles and graduates. Temperature and timing control are less critical than in conventional color printing. After exposing Ektaflex PCT film in darkness, you feed it into the Ektaflex printmaker (shown below). You prepare this beforehand by pouring in Ektaflex PCT activator (shown here in its bottle) and then placing a sheet of Ektaflex PCT paper on the printmaker tray. The machine laminates paper and film together; after only a few minutes, you can separate them to find a completely processed color print.

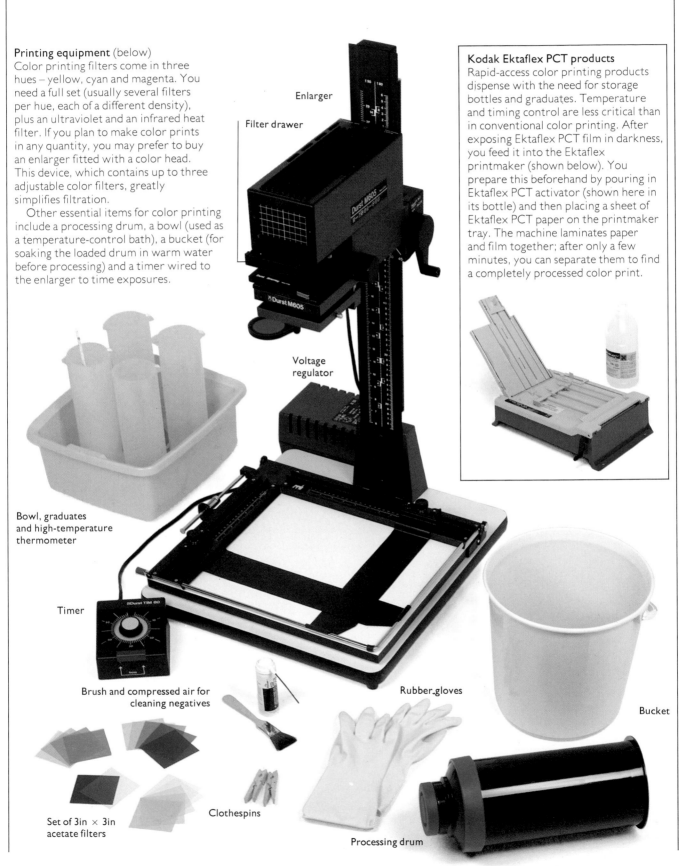

Enlarger

Filter drawer

Voltage regulator

Bowl, graduates and high-temperature thermometer

Timer

Brush and compressed air for cleaning negatives

Rubber gloves

Bucket

Set of 3in × 3in acetate filters

Clothespins

Processing drum

Mixing chemicals

The first step in any processing is to prepare the appropriate chemicals. Photographic chemicals come in concentrated liquid form or in packets of powdered crystals. Both need diluting with water to obtain a working solution. For good results, line up in advance all the materials to mix the chemicals. The picture below shows the basic items you need; follow the manufacturer's instructions exactly.

Although the mixing process varies according to the type of solution you are preparing, there are some general rules. First, wash containers and instruments thoroughly before and after mixing; any item not spotlessly clean may contaminate the solutions. Mop up spills as soon as they occur and keep work surfaces clean. Second, arrange bottles or packets of chemicals in the order in which they will be added, so that you do not reach for the wrong one by mistake. Always add chemicals to water, not the other way round. And make sure the water is the correct temperature before mixing. This is particularly important if you are using crystals because, if the temperature is wrong, they may not dissolve. To protect your skin, wear rubber gloves whenever you handle concentrated chemicals.

Store made-up solutions in clean, tightly sealed bottles to prolong shelf life. For convenience, you may wish to make up a large batch in advance. However, the life of some chemicals, once mixed, is limited so be sure to follow the manufacturer's advice about storage time. Finally, label each bottle clearly and precisely, with the date and code or description of the solution. A bottle labeled simply "developer" does not tell you if it is for color or black-and-white, or for film or prints.

Equipment for mixing chemicals
Processing chemicals, whether they are concentrated liquids in bottles (1) or crystals in bags (2), usually come in kit form. Rubber gloves (3) are advisable, especially when mixing the chemicals for color processing. You will need a large measuring graduate with clear markings (4) for water, and a smaller one (5) for measuring liquid chemicals. Use a darkroom thermometer (6) to test the temperature of water and solutions. A stirring rod (7) is needed if you are dissolving crystals. Pour the prepared solutions through a funnel (8) into storage bottles (9) – you can use empty household containers if you wash them thoroughly. Use a waterproof pen (10) and sticky labels (11) to mark the bottles, and store them out of reach of children.

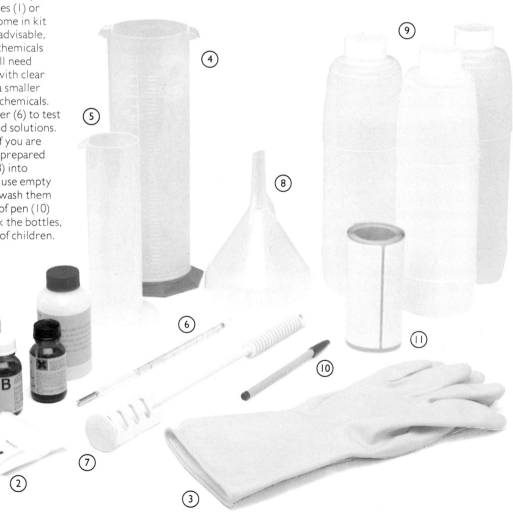

Mixing stages

The diagrams on this page demonstrate in a step-by-step sequence the basic procedures you need to follow when you are preparing any chemical solution for processing. If you live in a hard-water area or have grit in your water supply, you will obtain better results if you use distilled or deionized water for solutions. Alternatively, fit a filter over the faucet to remove impurities. In a permanent darkroom, the filter can be incorporated in the plumbing system.

1 – Wash thoroughly under clear, running water all the items of equipment you will use in making up the solutions.

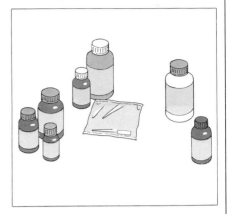

2 – Arrange the bottles or packets of chemicals in order of use, according to the manufacturer's directions.

3 – Measure the water into a large graduate. Test the temperature of the water with a darkroom thermometer. Correct mixing temperature is especially important if you are using crystals.

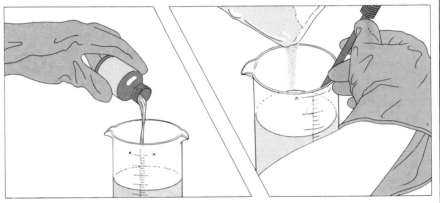

4a – Put on rubber gloves. If you are using concentrated liquid chemicals, pour in the contents of each bottle or measured amount in the correct order. Always add the chemicals to the water, not vice versa.

4b – If you are using powdered crystals, add the contents of one packet at a time in the correct order. Stir the solution gently with a rod to dissolve each chemical completely before you add the next.

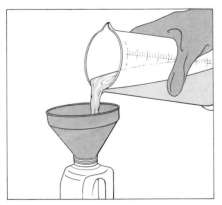

5 – Place a funnel in the neck of a storage bottle and pour in the mixed solution. Try to fill each bottle to the top to exclude air, so that the solution will keep longer. Close the bottles tightly.

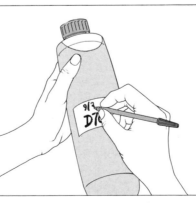

6 – Use adhesive labels and a waterproof marker to identify each bottle clearly and precisely. Include the date and a code or description of the preparation. Store the made-up solutions in a dark place.

7 – Wash graduates, funnel, stirring rod, gloves, thermometer and any other item that has come into contact with the chemicals. Leave the washed equipment to drain, and clean up work surfaces.

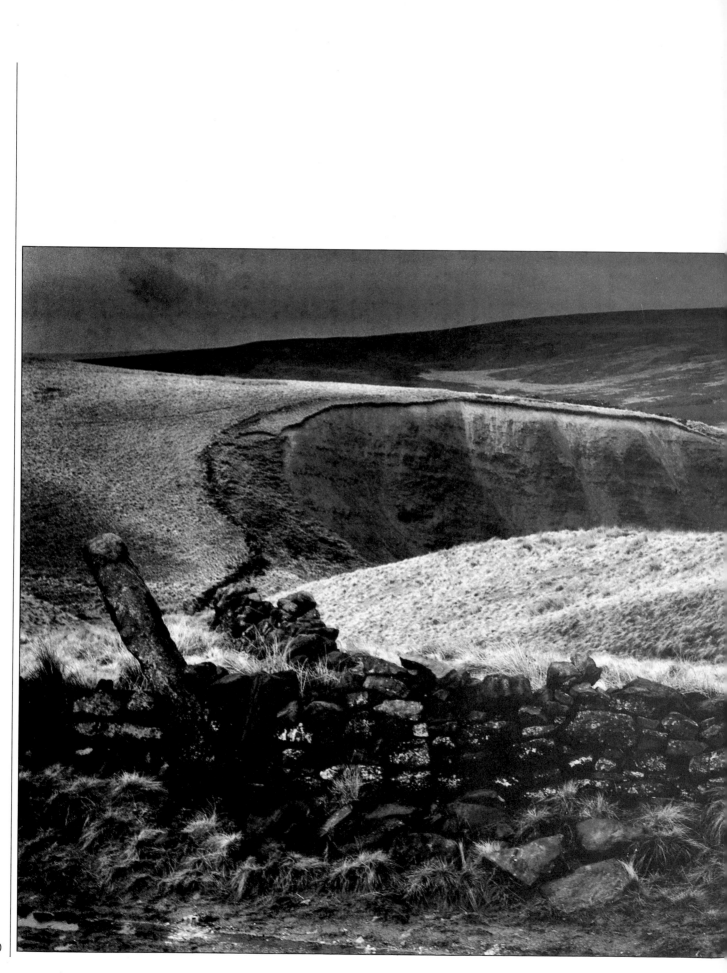

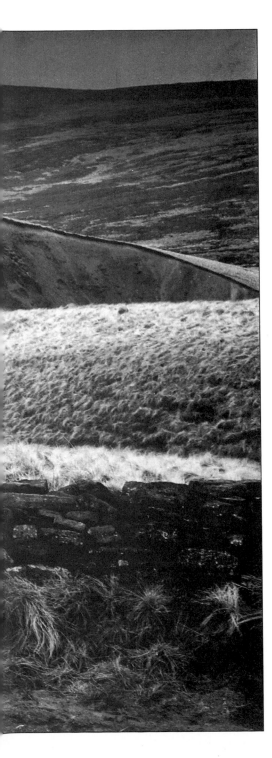

EXPERT BLACK-AND-WHITE

Processing and printing photographs yourself will enable you to realize the full potential of your best pictures. Achieving the best possible technical quality is only one of the rewards; the real satisfaction lies in creating a picture exactly the way you want it. You can correct compositional mistakes you made when you took the picture by choosing to enlarge just part of a scene; you can lighten or darken areas for a more pleasing result; or you can modify the overall contrast with different printing papers.

The following section covers in detail how to make a perfect black-and-white photograph – from loading film into the developing tank to special techniques for finishing your prints. The basic principles will help you to follow the somewhat more complex steps toward color prints explained later. With care and practice, you can produce pictures such as the one at left, combining technical excellence with a strongly individual creative approach.

The varied textures of a moor are rendered in precise detail on a home-printed image. Individual control over the exposure of each part of the print enabled the photographer to modify the sky from pale gray to a darker tone, thus strengthening the mood of the picture.

Understanding the chemical process

Just as awareness of how a camera works can help you to take better pictures, knowledge of what happens during processing and printing can improve your results in the darkroom. If you understand the chemical process, you have a better chance to strengthen less-than-perfect pictures by controlling and modifying treatment of the film or final print.

The box on the opposite page shows the structure of black-and-white negative film. A chemical agent — the developer — is used to amplify the changes caused by light striking silver halide crystals in the film emulsion. (The energy of light alone could convert the highly light-sensitive silver halide crystals into a visible image. However, this would require exposure times of many minutes in the camera.)

The longer film is left in the developer, the more silver halide crystals convert to pure silver, which is black in appearance. This metallic silver forms the grain that makes the image visible. Eventually, crystals not exposed to light will also convert, resulting in an overly-dark, or "dense", negative with little or no difference in tone between bright and shadow areas of the subject. To prevent this, you need to halt the developing action after a given time, depending on the type of film and developer used. You accomplish this with a stop bath — an acidic solution that immediatley neutralizes the alka-line developer.

After development, the film still contains unex-posed light-sensitive silver halide crystals. Fixer,

What happens during exposure

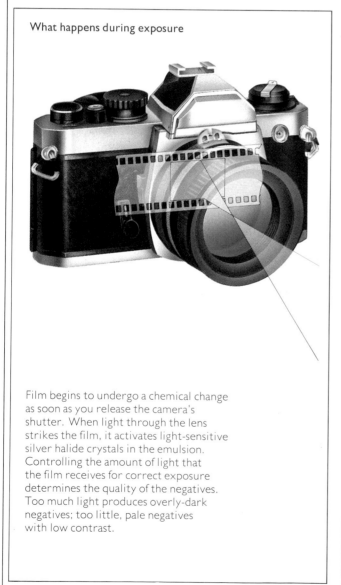

Film begins to undergo a chemical change as soon as you release the camera's shutter. When light through the lens strikes the film, it activates light-sensitive silver halide crystals in the emulsion. Controlling the amount of light that the film receives for correct exposure determines the quality of the negatives. Too much light produces overly-dark negatives; too little, pale negatives with low contrast.

What happens during processing

I – The latent image
The silver halide crystals that are struck by light when you take a photograph form minute specks of metallic silver. These specks, invisible even under a microscope, make up the latent image that the developer will work on. Fewer crystals — or none at all — are activated in parts of the image corresponding to the dark areas of the subject.

another acidic solution, turns these unwanted crystals into water-soluble salts that can be rinsed away. Correct fixing is important; if the fixer is left on the film too long, the silver converts into a compound that eventually makes the image dissolve. Insufficient fixing will leave some of the light-sensitive crystals on the film, and these will eventually cause the image to darken.

Processing prints involves steps similar to those followed in processing film. However, whereas film is sensitive to all the colors of light, requiring processing in total darkness, black-and-white printing paper reacts only to blue light. For this reason, red or yellow light is safe to use when you are black-and-white printmaking.

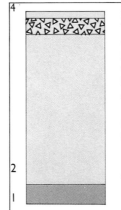

Black-and-white film structure

The diagram at left shows, in a magnified cross-section, the different layers of black-and-white negative film. A layer with anti-halation dye (1) prevents light from reflecting back through the emulsion from the film base (2), which is composed of flexible, transparent plastic. The base supports the emulsion (3) a mixture of silver halides suspended in gelatin. This is the light-sensitive layer that records the image. A further coating of gelatin (4) over the emulsion protects its delicate surface.

What happens during printing

2 – Development

Chemicals in the developing solution make the specks of silver enlarge until the exposed crystals turn black and the image becomes visible. The areas of unexposed crystals show up as pale and milky white because the developer does not convert these crystals to silver. Development halts when you immerse the film in a stop bath.

3 – The fixed negative

After developing, the image on the negative is complete but unstable. If exposed to light, the unconverted crystals will turn to metallic silver and darken the whole negative. Fixer dissolves the crystals, turning the milky, unexposed areas transparent. Washing removes any residual chemicals from the negative.

Printing paper, like film, has an emulsion of silver halides, but on a paper base instead of clear film. In the negative, tonal values appear reversed: light areas show as dark, and dark areas as light. Projecting the negative onto the paper, and then processing the paper in much the same way as film, reverses the negative to a positive reproducing the tones in the original scene.

Loading your tank

Because black-and-white film is highly sensitive to all the colors of light, you have to open the film and load it into the developing tank in complete darkness. If you are not sure that your darkroom is absolutely lighttight, you can use a changing bag, illustrated among the equipment at right. This is a special double-lined cloth bag that you can close and manipulate with the equipment inside, thus creating a totally dark environment for loading.

Developing tanks are designed to be lighttight so once the film is loaded and the lid of the tank is in place, you can continue processing in normal light. Two different types of tank are shown on the opposite page. Both are available in various sizes; the larger sizes are able to hold more than one reel of film for multiple developing. Each type of reel has advantages and disadvantages. The plastic edge-loading reel adjusts to fit any size film and is slightly easier for beginners to load. However, the reel must be absolutely dry before you load, or the film may stick or buckle instead of lying flat in the spiral grooves. The center-loading reel cannot be adjusted for different films, and the loading method may require a little practice. But once you have mastered the technique, the film will slide on smoothly even if the reel is not completely dry.

The techniques involved in loading film into a tank are quite straightforward. However, it is easy to make mistakes when you are working in the dark. A good idea is to practice the procedures a few times with the lights on, using an old roll of film. When you can handle each stage successfully with your eyes shut, have a final run-through in the dark. Following a few general rules will minimize the chance of error. Always begin with a tidy, well-organized working area. Put away anything you will not be using, and keep all necessary equipment where you can locate it easily. Work with blunt-end scissors to avoid scratching the film, and close the blades after use. If you are loading in a changing bag, check that everything is inside the bag before you remove the film from its light-tight casing. Make sure you can feel the difference between the film and its paper backing, so that you do not load the paper into the tank by mistake.

When you load the film onto the reel, take your time and never try to force the film if there is resistance. If the film jams, do not panic. Carefully unwind and reload it, checking that the reel is dry and the edges of the film are square with the spiral grooves. When the film is loaded, be sure that each coil lies correctly in an open spiral. If any sections touch or are twisted, development will be impaired. Drop the reel in the tank and replace the lid before turning on the lights.

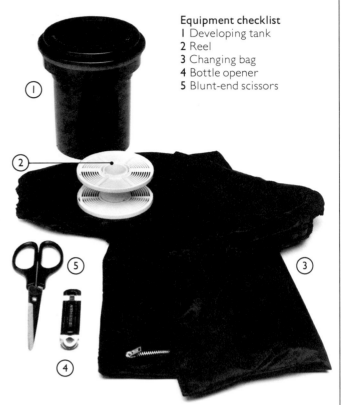

Equipment checklist
1 Developing tank
2 Reel
3 Changing bag
4 Bottle opener
5 Blunt-end scissors

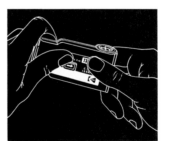

Opening 126 film
Twist to break open the cartridge, and remove the film spool. Slowly strip off the film's paper backing.

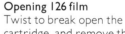

Opening 35mm film
With a bottle opener, pry off the cover at the end opposite to that from which the spool protrudes. Slide the film spool out of the cassette. Use scissors to square off the tapered film leader.

Opening 120 film
Carefully tear the paper seal on the roll and separate the film from the paper backing. Peel away the tape that attaches the end of the film to the paper.

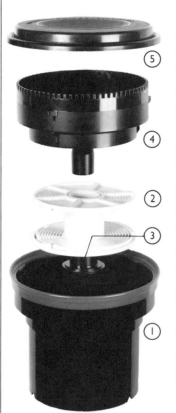

Tank with edge-loading reel

The components of an edge-loading tank are generally made of plastic. A light-tight container (1) holds one or more reels (2) with spiral grooves. The film is wound on from the outside toward the center, with two clips on the outer groove holding the leading edge of the film in position. Plastic edge-loading reels have adjustable halves to take different film sizes. A hollow black tube (3) fits inside the reel to funnel solutions into the tank. The tank lid (4) has a funnel that forms a light-tight channel to admit the liquid. When the lid is closed, the tank is completely lighttight. A cap (5) fits tightly onto the lid so that the tank can be turned upside down during processing.

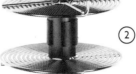
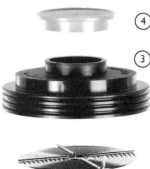

Tank with center-loading reel

The components of a center-loading tank are generally made of stainless steel. A container of variable size (1) holds one or more spiral reels (2) with a central core. A clip holds the end of the film, which is wound onto spiral grooves that start at the core and run to the outside. Center-loading reels are not adjustable, so you will need to buy a separate reel to fit every film size you use. The tank is closed with a light-tight lid (3), which has gaps around the inside so that processing liquids can be poured into the tank. A stainless steel or plastic cap (4) fits over the lid; when the cap is in position, the tank can be safely inverted during processing without liquids leaking out through the lid.

1 – Set an adjustable reel to the right width by sharply twisting the halves until they click into position.

2 – Line up the slots on the outer rim and, holding the film by the edges, feed the end into the outer groove.

1 – Hold the reel firmly with the sides vertical. Rotate the reel until the blunt ends of the spiral are at the top.

2 – Bow the film slightly between thumb and forefinger and insert the end into the clip in the core of the reel.

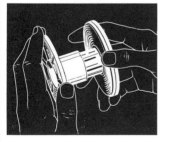

3 – Rotate the two halves of the reel alternately and in opposite directions, keeping the film smooth and straight.

4 – Cut the end off the roll or magazine to leave a neat edge when the whole film has been wound into the grooves.

3 – Continue to bow the film as you rotate the reel away from it. Gently slide the film on; do not scrape the edges.

4 – When the film is wound on, cut it free. Check that each coil of film lies flat and that each groove is used.

Developing your film

Developing film is the most crucial of all darkroom tasks. Although errors at later stages in the darkroom process can be remedied, careless development techniques can waste all the effort put into taking the pictures by ruining the film. You can get good-quality negatives only if you follow methodical procedures, as shown on the opposite page.

The key to good processing is consistency. Try to use just one type of film and developer at first, and keep strictly to the recommended time and temperature – usually 68°F (20°C) – whenever you develop a film. Take special care when pouring solutions into and out of the tank. Some tanks take as long as 20 seconds to empty or fill, and if you vary your filling and emptying routine you can increase development time by up to 15 percent. Thus, follow a regular procedure, such as starting to time development as soon as the tank is full and stopping when it is com-

pletely empty. Overly-vigorous agitation of the developing tank can cause as much variation in development as inaccurate timing or poor temperature control can, and may result in streaks forming on your film. So standardize the way you invert the tank, too.

After developing and fixing, you must wash and dry the film. Care at this stage can save much time and effort later. Particles of dust or grit that land on the wet film will show up on your prints as white spots, which you must laboriously spot out with a brush. To prevent such marks, give your film a final rinse in filtered or distilled water, then add the correct amount of wetting agent so that water drains evenly off the film without leaving drying marks. You can speed up this process by gently removing excess water with your fingers or with a soft sponge. Finally, hang the film to dry in a dust-free place.

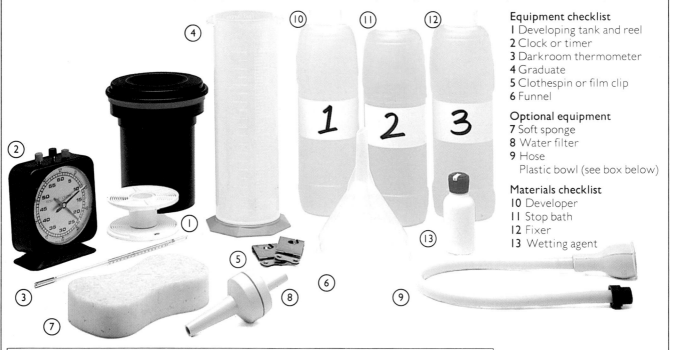

Equipment checklist
1 Developing tank and reel
2 Clock or timer
3 Darkroom thermometer
4 Graduate
5 Clothespin or film clip
6 Funnel

Optional equipment
7 Soft sponge
8 Water filter
9 Hose
Plastic bowl (see box below)

Materials checklist
10 Developer
11 Stop bath
12 Fixer
13 Wetting agent

Temperature control

The usual temperature for developing black-and-white film is 68°F (20°C), and developer should be within 1°F ($\frac{1}{2}$°C) of this for consistent results. If you dilute your chemical stock with water at the right temperature, you should have little difficulty maintaining this temperature during development; but in very cold or hot rooms you may have to stabilize the temperature of the developer by using a bath of water warmed or chilled to 68°F. Keep the chemicals and tank in this water bath just prior to processing, and store the tank in the bath when not agitating it.

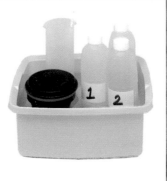

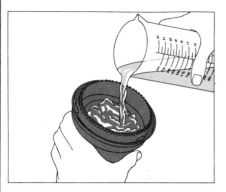

1 – Fill the developing tank with developer, tilting the tank to help speed the flow of solution. Remember to check that the developer is at the correct temperature and that there is enough of it to cover the film reel.

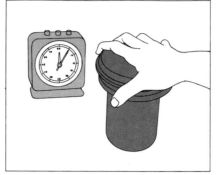

2 – Start timing as soon as the tank is full, then replace the cap and tap the tank a couple of times on the work surface to dislodge air bubbles from the surface of the film. Air bubbles leave small round marks on the negatives.

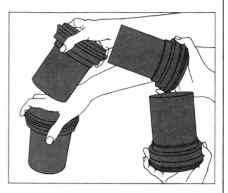

3 – Agitate the tank for five seconds every minute by gently inverting it several times. Hold the lid tightly on the tank. A minute or so before the full development time has elapsed, measure out the correct quantity of stop bath.

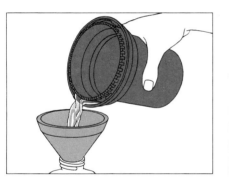

4 – Remove the cap and pour out the developer the instant the specified time has elapsed (see the instructions packed with the chemicals). Funnel reusable developer into a storage bottle. Pour single-use developer down the drain.

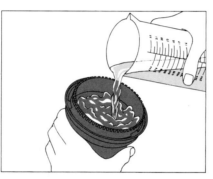

5 – Pour in stop bath immediately after draining the developer, and agitate continuously for about 30 seconds. Without opening the tank, pour the solution into a bottle. You can reuse stop until it turns from yellow to blue.

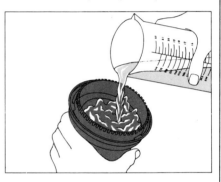

6 – Fill the tank with fixer. Agitate continuously for half a minute, then intermittently until the full fixing time is up. Drain the fixer back into its bottle, and remove the lid from the tank to wash the film.

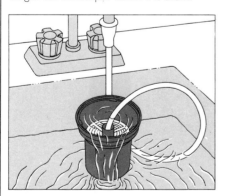

7 – Wash the film for at least half an hour in running tap water at between 65° and 75°F (18°–24°C). A hose pushed to the base of the tank makes the washing process more efficient. Give the film a final rinse in filtered or distilled water.

8 – Add the correct amount of wetting agent to the water in the tank. This helps water drain evenly off the drying film. With too little wetting agent, water drops will leave drying marks; too much leaves greasy smears on the film.

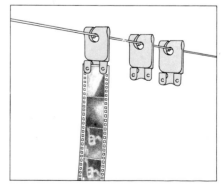

9 – Hang up the film to dry in an area that is as dust-free as possible – the bathroom is usually a good place. Then thoroughly wash and dry the tank, reel, and all other equipment to remove chemical residues.

Learning from negative faults

When your film is completely dry, cut it into short pieces. From 36-exposure film, cut six strips, each six negatives long. This way you will have lengths that fit neatly onto an 8 × 10in (20.3 × 25.4cm) sheet of paper for contact printing, and which you can store in standard-sized negative filing sleeves. Slide the negatives into these protective envelopes as soon as you have cut the film up. If you leave negatives lying around loose, they will soon get scratched and dirty.

With the strips of film in manageable lengths, examine them carefully with a magnifier. If you have made any major errors in development, such as pouring in the solutions in the wrong order, the problem should be clearly visible. The examples of faulty processing shown on the opposite page will help you to pinpoint exactly what went wrong while you were developing the film.

Marks and blemishes are not the only faults you may detect. Negatives may be too dark or too light, or they may have too much or too little contrast. After development, it is difficult to remedy these faults, though you may be able to minimize their effects with careful printing. The value of identifying errors is that you can prevent them from recurring, by adjusting exposure or development, or both.

If your negatives seem consistently too dark but show normal contrast, try setting your camera's film speed dial one stop higher than your film's ISO number – and vice versa if the negatives are too pale. If the fault is a lack of contrast, increase the development time for your next batch of film or, conversely, cut the time if there is too much contrast. Change development times progressively and by small amounts; a 10 percent increase or decrease is often enough to improve contrast.

Normal negatives
If you expose your film correctly and control development carefully, your negatives should resemble this one – neither too dark nor too light, and with detail visible in all parts of the subject. Such a negative enlarges well and produces rich prints.

The edge markings should be clearly visible. If they are weak and pale, you have underdeveloped the film

The deepest shadow in the subject should appear clear – the same tone as the unexposed film edges

The highlights should not be too dense – you should be able to read type through even the darkest area

Pale, gray negatives (left) with pale edge numbers indicate that the film was underdeveloped. Check that you diluted the developer correctly and that time and temperature were also correct.

Dark, contrasty negatives (right) with black edge numbers are evidence of overdevelopment. Check if developer was too warm or too concentrated; if neither, you left the film developing for too long.

Pale negatives (left) with normal edge markings indicate underexposure. Check that your camera's exposure meter and shutter are working correctly. If so, you may have set too fast a film speed.

Dense negatives (right) with average contrast and normal edge marks are overexposed. Check camera, as for underexposure. If there is no fault, you may have set too slow a film speed.

Milky, translucent negatives (left) have not been adequately fixed. Double check the fixer strength and the specified fixing time. Mix some fresh fixer solution, and refix the film.

Gray fog (right) covering not just the negative but the borders as well shows that light reached the film while you loaded it into the tank. Check your darkroom for light leaks.

Blotchy opaque areas (left) are the result of careless loading. Concentric spirals of film on the reel have stuck together, preventing the solutions from reaching the film.

Small pale circles (right) are caused by air bubbles sticking to the film when you pour in the developer. Rap the developing tank several times to knock off the bubbles.

Blank film (left) could mean one of two things. If edge marks are visible (top), the film was unexposed. If there are no edge marks (bottom), you poured fixer into the tank before the developer.

Half-obscured images (right) result when the film is not fully covered by developer (top) or fixer (bottom). Check the solution volumes for your tank, and be sure that the reels cannot move up during agitation.

39

The enlarger

The enlarger is the single most important item in any darkroom. It operates on the same principle as does a movie projector. A lamp, switched on for a predetermined length of time, shines downward through the negative and then through a lens. The lamp projects an enlarged image of the negative onto a sheet of printing paper placed in an easel (or masking frame) on the enlarger's baseboard.

The lamp, negative and enlarging lens (and the filter drawer used with color negatives or transparencies) are housed in a part of the enlarger known as the enlarger head. You can crank or slide this up or down on its supporting column to vary the distance between the lens and the printing paper, and thereby control the size of the final print. The higher you raise the enlarger head, the larger your finished picture will be.

Below the lamp, inside the enlarger head, is a device that spreads the light evenly over the negative. In most enlargers designed primarily for black-and-white film, this takes the form of several convex lenses collectively termed a condenser.

Every time you alter the height of the enlarger head, you need to refocus the image. To do this you turn a focusing knob that moves the enlarging lens toward or away from the negative. As with a camera lens, an enlarging lens has an adjustable diaphragm that regulates the amount of light passing through it. Aperture setting and exposure time interrelate exactly as they do in a camera. However, with enlargers, exposures are in seconds rather than in fractions of a second.

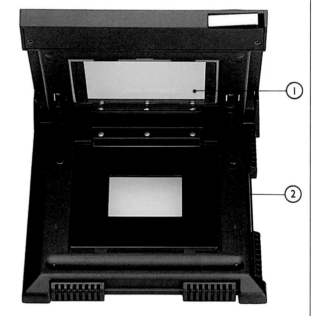

The negative carrier
A negative carrier holds the negative flat between two plates, each with a cutout through which the light passes. Some types come with a range of individual metal holders for different negative formats. Others keep the negative in position between two sheets of glass. This glass-sandwich type requires constant and careful cleaning of all four surfaces but it is preferable when you need to keep the negative absolutely flat – for example, when you are making a big enlargement or using a long exposure time. A sensible compromise, illustrated above, is to combine one glass holder (1) with one of the metal type (2).

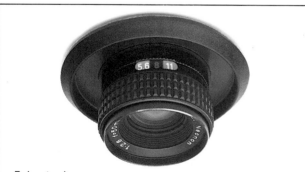

Enlarging lenses
A good enlarging lens is essential if you want to make prints worthy of your best negatives. Compared with camera lenses, even the best enlarging lenses are inexpensive. Choose a lens that suits the size of your negatives: a 50mm lens for 35mm film, and an 80mm lens for rollfilm.

Because enlarging lenses are used in darkness, they have audible click stops, so that you can choose the aperture by counting clicks. Some types also have an illuminated f-stop scale, as shown above.

Making large prints
If you wish to make a very large print, the lens-image distance may need to be greater than the height of the enlarger column allows. With some enlargers, you can overcome this by turning the enlarger head to project the image onto a wall (as shown above) or downward onto the floor.

Tilting the head
Some enlargers are so constructed that you can tilt the head at an angle to the baseboard and column, as the diagram above shows. The purpose of this is to give you more control over the image – for example, to correct converging vertical lines in a picture, caused by tilting the camera.

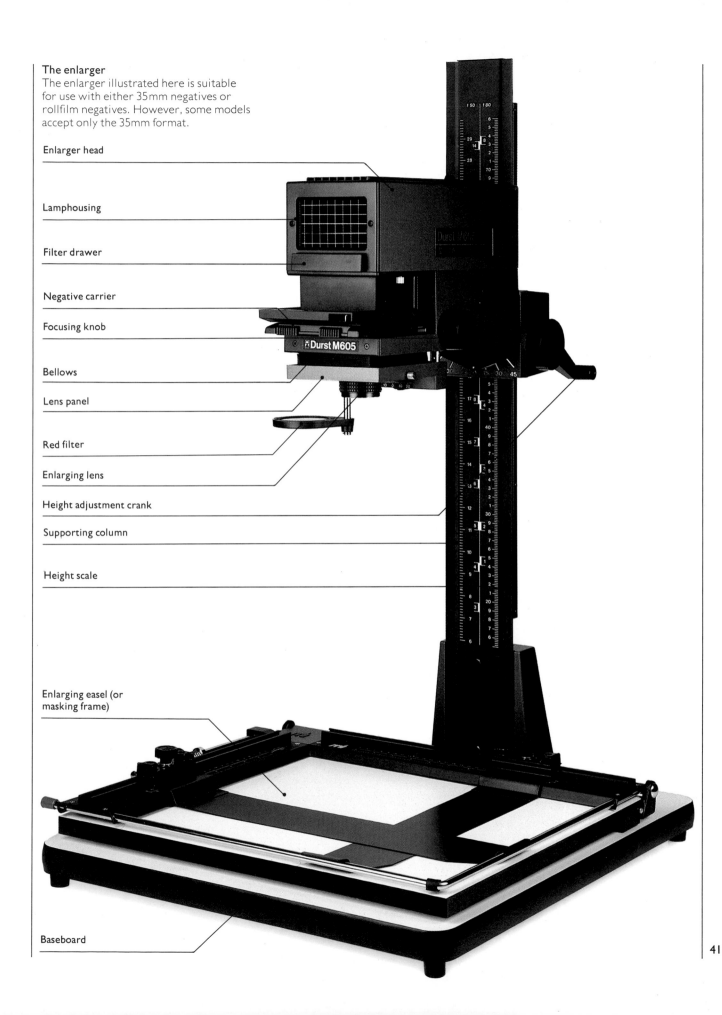

The enlarger

The enlarger illustrated here is suitable for use with either 35mm negatives or rollfilm negatives. However, some models accept only the 35mm format.

Enlarger head

Lamphousing

Filter drawer

Negative carrier

Focusing knob

Bellows

Lens panel

Red filter

Enlarging lens

Height adjustment crank

Supporting column

Height scale

Enlarging easel (or masking frame)

Baseboard

Durst M605

Making a contact sheet

A contact sheet shows a positive image of every frame on a roll of film, so that you can easily assess which of your pictures you want to enlarge. And because a ring binder can hold, side by side, both the negatives and the contact sheets made from them, you can use a contact sheet to locate a negative quickly without examining each strip of negatives against the light.

Making a contact sheet is simple, as the pictures at right show. Using a sheet of glass to press your negatives tightly against a piece of photographic paper, you shine light through this sandwich of glass and negatives onto the paper. Then you make the image visible just as you do when processing film – by immersing the paper in developer, stop and fixer. The developer must be specially formulated to process paper prints. However, the other two solutions can come from the same concentrates or powders

that you used when processing the film, though you may have to follow different diluting instructions.

The process of exposing and developing a contact sheet can take place in yellow safelighting, giving you a clear view of what you are doing. Unlike film, photographic paper is sensitive to only one color of light – blue. Thus, the yellow safelighting has no effect on the printed image.

The fixer bath removes even this sensitivity to blue light, so once your contact print has been in the fixer for half a minute or so, you can switch on the normal room lighting and examine the results. Now is the time to judge whether you gave your print the correct exposure. If the sheet is too dark, have another try, cutting the exposure time by half, or else closing down the enlarger lens by one stop. Conversely, if the sheet is too light, double the time, or open up the lens aperture by one stop.

Making and storing contacts
A finished contact sheet (1) shows every negative actual-size, but with the tones reversed. To press negative and paper together for a contact print, use a sheet of glass with taped or polished edges (2). A contact printing frame (3) makes the job easier by holding all the materials. If you use transparent negative file pages (4), you need not remove individual negative strips; you can lay the whole page on the printing paper. This saves time and keeps negatives cleaner, though it does require a larger size of paper than printing with individual strips. Store the contact sheets in a file (5) alongside the negatives.

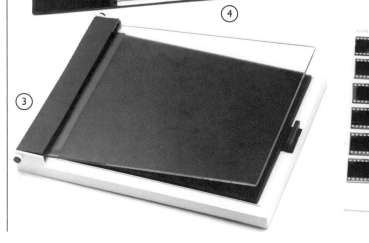

Equipment checklist
Enlarger
Safelight
Clock or timer
Darkroom thermometer
Graduates
Three processing trays
Two pairs of print tongs
Sheet of glass, or special contact
 printing frame
(Rubber gloves are advisable if you
 have sensitive skin)

Materials checklist
Box of resin-coated printing paper
 (see pages 52-3)
Developer, stop and fixer

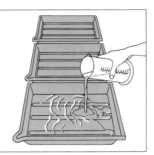

1 – Fill trays with developer, stop and fixer to a depth of about $\frac{3}{4}$ in ($1\frac{1}{2}$ cm). The solutions should ideally be at 68°F (20°C), though temperature is not critical; processing simply gets faster as the temperature rises.

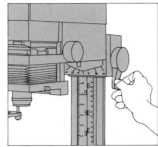

2 – Move the enlarger head up the column until the light from the lens easily covers the glass or contact frame. Close the lens aperture to f/11, and turn out the room lights and the enlarger lamp. Switch on the safelight.

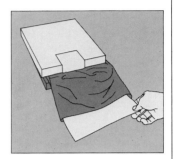

3 – Take a sheet of paper out of its box and inner envelope and reseal the package against light. Place the paper, emulsion (shinier) side up, on the enlarger baseboard or on the foam base of the contact frame.

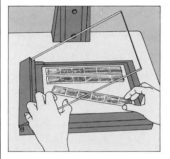

4 – Lay the negatives, emulsion (duller) side down, on the paper, handling them by the edges. Cover with the glass sheet. If you are using a contact frame, lower the glass surface and lock it into position.

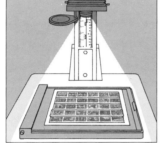

5 – Switch on the enlarger lamp for about 15 seconds to expose the paper, then lift the glass carefully and put the negative strips back into their filing sheet before removing the printing paper for processing.

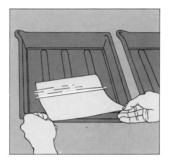

6 – Slide the paper, emulsion side down, into the tray of developer, then gently rock the tray by lifting and lowering one corner. After half a minute, you can turn the paper over. Development takes about 90 seconds.

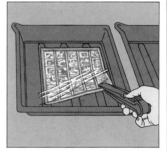

7 – Lift the paper from the developer, using a pair of print tongs. Allow the print to drain for a moment, then lower it into the stop bath. Make sure that you do not contaminate the tongs with the acidic stop solution.

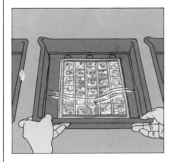

8 – Rock the tray of stop for about half a minute, then – using the second pair of tongs – transfer the paper to the fixer tray. Both stop and fixer are acidic, so you can safely use one pair of tongs.

9 – Agitate the fixer continuously for the first 15 to 30 seconds, then occasionally until a total of about two minutes has elapsed. Lift the paper out of the fixer, and lower it into a tray of water.

10 – Wash the print in tap water for four minutes. The water temperature should be between 70° and 75°F (21° – 24°C). If your tap water is too cold, use five changes of warmed water instead.

11 – Wipe drops of water from the surface of the print, then dry the paper, either by hanging it up or by laying it out on a flat, absorbent surface. You can speed drying with a hair dryer.

Preparing to print

By examining your contact sheet with a magnifier, you can get an approximate idea of which negatives are worth printing. However, do not discard images simply because they are darker or lighter than the rest. This is a result of over- or underexposure in the camera, and within limits you can correct the faults at the enlarging stage.

Once you have identified the most promising images on the contact sheet, refer back to your negatives and locate the selected frames. Use a loupe or a powerful magnifying glass, and look very carefully at the negatives. Fine detail that was indistinct on the contact sheet will be clearly visible. Make sure each picture is perfectly sharp, with no evidence of camera shake, and that no processing faults are visible. Care in picking out only the best frames

to print will save you from a discouraging struggle with indifferent negatives, which invariably produce mediocre results.

Having chosen the negative you want to print, follow the step-by-step procedure illustrated on the opposite page in preparation for printing. Resist the temptation to rush through or skip any of the nine steps, because every one of them is an essential part of the enlarging process. For example, cleaning the negative – step 2 – is tedious, yet every speck of dust that lands on your negative will show up as a white speck on the print. As you gain experience in darkroom work, you may want to introduce refinements. For example, to focus the image on the easel with extra precision, you can use a focusing magnifier, as described below.

Equipment checklist
1 Enlarger
2 Enlarging easel
3 Soft brush or compressed air can

Optional equipment
4 Focusing magnifier

Using a focusing magnifier
For really sharp prints, you must focus the enlarger precisely. If you are making a big enlargement, or printing from a very dense negative, you may find that the image on the easel is so dim that you have difficulty in finding the precise point of sharp focus. A focusing magnifier makes this much easier. Place the magnifier in the center of the easel, so that the mirror of the magnifier reflects a greatly enlarged view of the center of the negative up into the eyepiece. If the picture is sharp, you will clearly see a sharp image of the grain of the film, as at left below. Out-of-focus images show as a gray blur, as illustrated at right below.

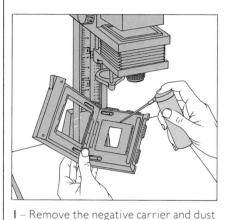

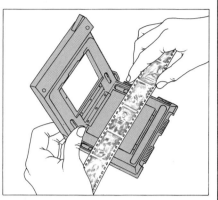

1 – Remove the negative carrier and dust it with a brush or a jet of compressed air. If the holders are glass, check that each surface is free of fingerprints.

2 – Clean the negative in a similar way. To reveal dust, hold the negative in the enlarger's beam, so that the light falls obliquely across the film surface.

3 – Slip the negative into the carrier, and check that all of the frame you plan to print is visible within the window of the carrier.

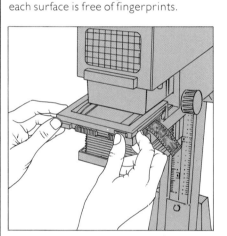

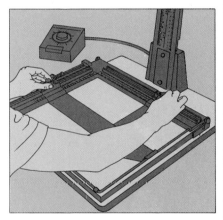

4 – Replace the carrier. With some enlargers, you have to lower the lamp housing onto the carrier to press the negative flat. Turn out the room lights.

5 – Open up the enlarger lens to its largest aperture. This ensures that the image on the baseboard is as bright as possible – and thus easy to focus.

6 – Set the easel to the paper size. Then slide in a sheet of blank processed paper to cover the easel and provide a white surface on which you can get exact focus.

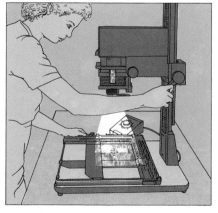

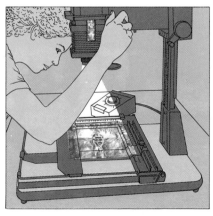

7 – Switch on the enlarger lamp, and raise or lower the head until the negative image on the easel is composed roughly as you want it on the print.

8 – Turn the focusing control until the picture appears sharp. This changes the image size, so you may have to readjust the head, then fine-tune the focusing.

9 – Close down the lens to the working aperture – f/11 is a good starting point – then remove the focusing sheet from the easel and switch off the enlarger.

Making an enlargement

Just as film requires carefully judged exposure to produce a good negative, a sheet of printing paper requires just the right amount of light to produce a print that is neither too dark nor too pale.

To find out how much light the paper needs for the image you are projecting, you must make a test print. This is a strip of paper cut from a full sheet, on which you print a section of the negative. But instead of giving the whole strip the same exposure, you follow the procedure shown on the opposite page (steps 1 to 8) to make a series of exposures of increasing duration. After processing the test strip, you can judge which time produced the best results, and expose the full print accordingly (steps 9 to 12). The box below will help you to work out how much exposure each section of the test should receive.

For the test to provide a reliable guide to exposure, you must process the strip – and the print that follows – with a little more care than you take when processing a contact print. When you mix the developer, use water at 68°F (20°C), or warmer if the developer concentrate is cold. This way the temperature of the developer should be right for developing both the test and the print. Do not worry if the developer temperature falls one or two degrees during your printing session – such a small change is unimportant. In a cold room, you can prevent excessive cooling by standing the tray of developer in a larger tray of warm water. The temperatures of the stop and fixer baths are less crucial than that of the developer.

Processing time is significant, too. With resin-coated paper (the most common type of photographic paper), your test and print will need about one and a half minutes in the developer. Make sure that you use exactly the same developing time for the print as you did for the test, or your result may be unsatisfactory. If the test strip appears to be darkening much too rapidly in the developer, resist the temptation to lift the paper from the tray prematurely. A half-developed test strip has about as much value for exposure estimates as no test at all.

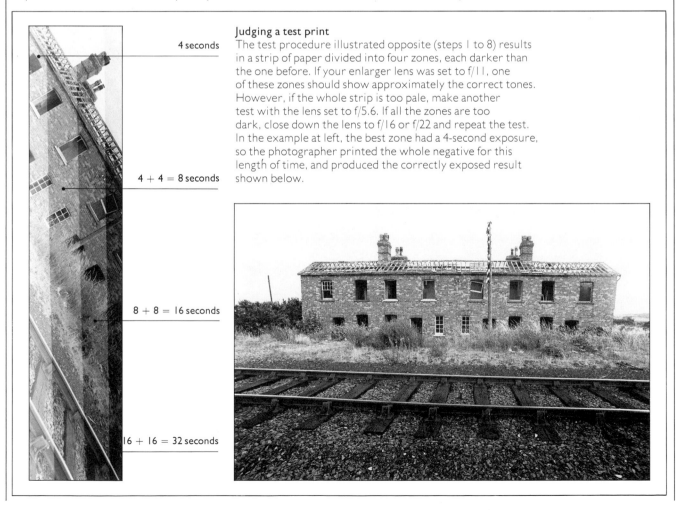

4 seconds

4 + 4 = 8 seconds

8 + 8 = 16 seconds

16 + 16 = 32 seconds

Judging a test print
The test procedure illustrated opposite (steps 1 to 8) results in a strip of paper divided into four zones, each darker than the one before. If your enlarger lens was set to f/11, one of these zones should show approximately the correct tones. However, if the whole strip is too pale, make another test with the lens set to f/5.6. If all the zones are too dark, close down the lens to f/16 or f/22 and repeat the test. In the example at left, the best zone had a 4-second exposure, so the photographer printed the whole negative for this length of time, and produced the correctly exposed result shown below.

1 – Cut a strip of printing paper about two inches (5cm) wide. Put the remainder back in the black envelope, and close the box.

2 – Swing the red filter over the lens to prevent the blue-light-sensitive paper from being exposed. Turn on the enlarger lamp.

3 – Position the paper in an area of the image that shows both dark and light tones. Turn off the lamp and swing the red filter aside.

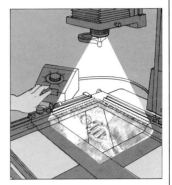

4 – Turn on the enlarger lamp to expose the whole test strip. After four seconds have elapsed, switch the lamp off again.

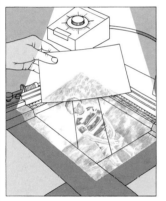

5 – Cover a quarter of the paper with a piece of cardboard and expose the rest of the test print – again, for a four-second period.

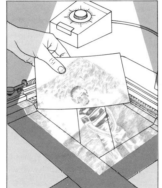

6 – Move the cardboard so that it covers half the strip of paper, and make another exposure, this time for eight seconds.

7 – Move the cardboard again, so that it now covers three-quarters of the paper. Expose the remaining quarter for 16 seconds.

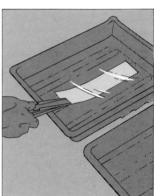

8 – Process the test print and then pick the zone in the strip that shows the best tones. Note the exposure time given for that zone.

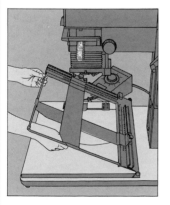

9 – Place a full sheet of paper on the easel, swing the red filter across, and turn on the enlarger to make a final check on composition.

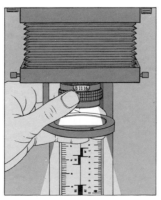

10 – Check that the lens is set to the correct aperture, then switch off the enlarger lamp and swing the red filter out of the light path.

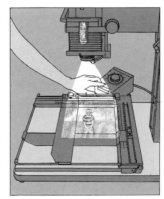

11 – Switch on the enlarger to expose the paper. After the time indicated by the test print has elapsed, switch off the enlarger lamp.

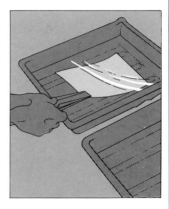

12 – Process the print as before. Make sure that the print stays in the developer for the same time as the exposure test.

Cropping the image

Because printing paper formats and negative formats do not correspond exactly, you will tend to crop out some part of a negative image if you are projecting it to cover an entire sheet of paper in the darkroom. More creative cropping comes into play when you deliberately choose only part of the negative for exposure so as to improve the picture. For example, you may have unwanted details at one or more edges of the frame because you could not get close enough to your subject or lacked time to compose the picture satisfactorily in your viewfinder. In a landscape, you may wish to alter the position of the horizon for a more effective composition. Or you may simply decide on a print format that is better suited to the subject, as exemplified in the center picture shown here.

A contact sheet helps you plan selective enlarge-

ments that correct or improve a picture. By manipulating a pair of L-shaped masks, as shown below at left, you can use the contact sheet to judge in advance the effect of different croppings. Once you are satisfied with a crop, adjust the masking frames of the enlarging easel to show exactly the same area of the picture before inserting the printing paper and making the exposure.

An enlarger suitable for a home darkroom generally allows a maximum print size of between 11 × 17in (28 × 43cm) and 16 × 20in (40 × 50cm), depending on the model. This enlarging capability allows you to blow up small portions of the frame onto normal-sized sheets of paper. Every time you raise the enlarger head to increase the image size, you must set a proportionately longer exposure time, because the light now has to cover a wider

Planning a crop
To preview the effect of a crop, cut two L-shaped pieces of cardboard. Then, as illustrated at left, hold them over the chosen image on the contact proof sheet so that you have a continuously adjustable frame you can use to change the size and proportions of the image area. Once you have settled on the best framing, use the pieces of cardboard as a stencil to mark the frame on the contact proof with a grease pencil. If you make a mistake or change your mind, you can remove the pencil marks by rubbing gently with a wad of cotton.

Cropping on the enlarging easel
Most enlarging easels have two adjustable masking blades, and two fixed ones. These cover the edges of the paper to give the print white borders. To crop a print, lift the hinged frame as shown at left and set the paper stops (1) to the required border width. Then lower the frame and slide the adjustable blades (2) until the area between them is the size and shape of the print you want to make. Insert the paper and make the exposure. After processing, trim the print to remove unwanted white paper.

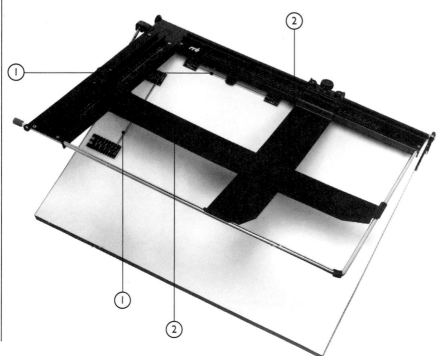

area. If you double the width of the print, you should quadruple the initial exposure time.

For a given degree of enlargement, you can easily judge the new exposure time by using one of the simple enlargement calculators available from some manufacturers of darkroom materials. If you plan to make prints regularly in a number of different formats, mark the supporting column of your enlarger with a scale indicating exposure times for different print sizes, as explained in the box on this page at right.

When working with the enlarger head raised at or near its full height, be sure to check that it is perfectly stable. Keep as still as possible while making the exposure, and beware of vibrations from traffic or from activity elsewhere in the house. The slightest shake of the enlarger will blur your picture.

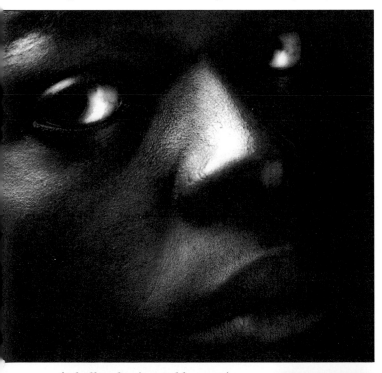

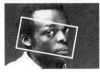

A shallow horizontal format is appropriate for this low-key close-up portrait. By masking a contact sheet as diagrammed on the opposite page at top, the photographer found a crop that made the image far more arresting as the basis for a print than was the 35 mm negative as a whole. The crop above shows only the center of the picture, excluding the shirt collar and a large highlight on the forehead. The photographer transferred the composition onto the easel, as explained in the caption at left, before making the exposure.

Marking your enlarger

To speed up your estimates of the new exposure times required when changing print sizes, it is sensible to mark typical exposure settings on an improvised scale on the supporting column of your enlarger, as shown below. First, set the enlarger to its smallest print size and make a test strip from a negative of average density. Mark the time that gives the best result on the enlarger column, just below the head. You can use an adhesive label for this, or a felt-tipped marker if you have to write on a metal surface.

Then, set the enlarger to give progressively larger print sizes, and for each one calculate a new exposure by squaring the increase in print size. For example, if the smallest print is 4 inches across and your next size up is 6 inches, the size increase is 6/4, or $1\frac{1}{2}$. Squaring this gives the exposure increase – $2\frac{1}{4}$. Thus, if the smaller print needs 5 seconds exposure at f/11, the 6-inch print will need $5 \times 2\frac{1}{4} = 11\frac{1}{4}$ seconds at the same aperture. At the larger print sizes, keep exposure times down by noting the next larger aperture and halving the time.

If you follow this procedure and mark all the exposures in the appropriate position on the enlarger column, you will have a quick-reference scale that will apply to any average negative. Negatives of greater or lesser density than average will require correspondingly longer or shorter exposures.

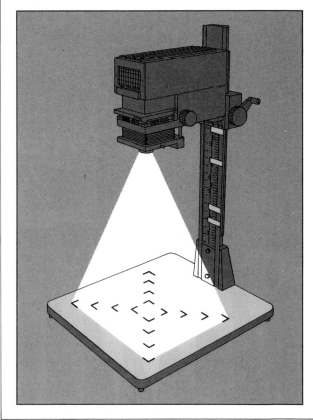

Papers and contrast

Negatives vary greatly, not only in their overall lightness or darkness but also in their degree of contrast. If you take a picture in dull or flat light, the negative will show low contrast, with little variation between the light and dark areas of the scene. On the other hand, if the day is bright and sunny, you will get a high-contrast negative with extreme differences between the lightest highlights and the deepest shadows. Incorrect exposure or development also affects the contrast of the negative. To cope with these variations, photographers use a range of printing papers that regulate contrast.

There are two basic types of black-and-white printing papers, and they control contrast in different ways, although the effect is very similar. The first type is graded from soft to hard, with corresponding numbers from 0 or 1 to 4 or 5, depending on the brand. If a normal negative – one with average contrast, showing a full, even range of tones from light to dark – is printed on very soft paper, the result will be a flat print with excessively low contrast. Similarly, the hardest paper will produce an excessively high-contrast print. Normal, or grade 2, paper will produce a print with a normal contrast range. The effects of printing a normal negative on different grades of paper are shown below, at right. To obtain prints with balanced contrast from all your negatives, you will need to buy several different grades of paper.

Alternatively, you can use the second type of printing paper, known as variable-contrast. You control the contrast by means of filters, graded from orange to magenta (below, at left). The filters change the color of the light used to form the image on the paper, and so affect the degree of contrast. Most enlargers have a filter drawer above the negative carrier to hold an acetate filter of the color you select. A few enlargers have no filter drawer. Instead, a gelatin or plastic filter fits into a holder below the lens. The variable-contrast method of printing is economical and convenient, and small stores may stock only this type of paper, rather than the space-consuming graded papers. However, for very high-contrast prints, the highest-grade papers produce slightly better results. You may want to keep a stock of both high- and low-contrast papers, in addition to your variable-contrast paper, to extend your range.

A choice of papers or filters enables you to make normal-contrast prints from high- or low-contrast negatives, as illustrated on the opposite page. But you also gain creative control: you can heighten contrast to give an image punch and drama, or reduce contrast to soften lines and features.

Filters

The acetate filters shown below are for use with variable-contrast papers. They are graded from soft to hard, and numbered accordingly. An orange No. 0 filter produces the lowest-contrast result, while the highest-number magenta filter gives the most contrast. Filters may need trimming to fit the enlarger's filter drawer (right) and different filters need different exposure times. Use the dial provided with the filter kit to work out the correct exposure for each one.

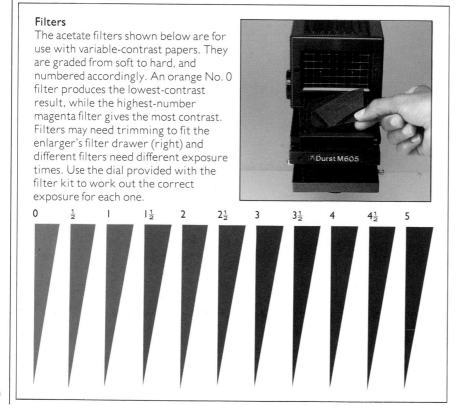

Contrast-graded papers

Graded papers come in individual packs and range from very low to very high contrast. The higher the number, the harder the paper and the higher the contrast. The prints below were made from a normal negative on graded papers ranging from ultrasoft to ultrahard.

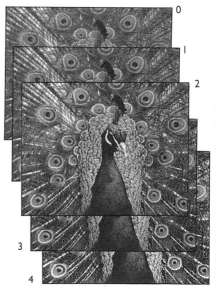

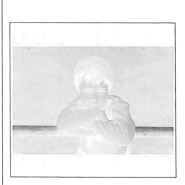

Raising contrast

A negative with low contrast (above) has tones mostly in the middle range, with no strong dark or light areas and little tone separation between the different parts of the image. Printing on normal-grade paper (inset, right) produced a picture without rich blacks or white highlights. The result is a lifeless, muddy image. Printing the negative on harder, grade 4 paper (right) gave a much more satisfactory result. The high-contrast paper has removed some of the uniform gray tones in the image, emphasizing the distinction between the lightest and darkest areas so that the contrast appears to be balanced.

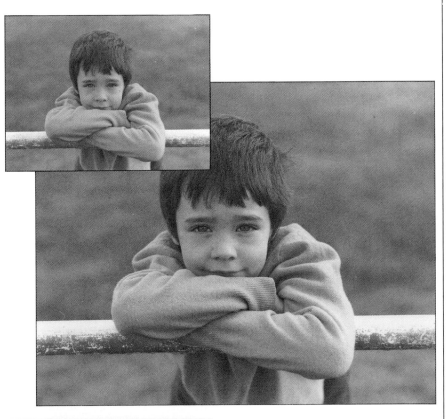

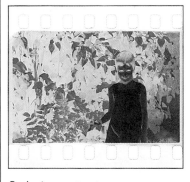

Reducing contrast

A negative with high contrast (above) shows almost clear shadow areas and very black highlight areas, with few intermediate gray tones. Printing on normal, grade 2 paper (inset, right) rendered the extreme tones as they appear in the negative. Detail is lost in both the shadow and highlight areas of the image, with the brightest highlights burnt out. The overall effect is harsh and hard-edged. When the same negative was printed on soft, grade 1 paper (right), more of the middle gray tones were reproduced. As a result, the extreme light and dark tones have become much less apparent.

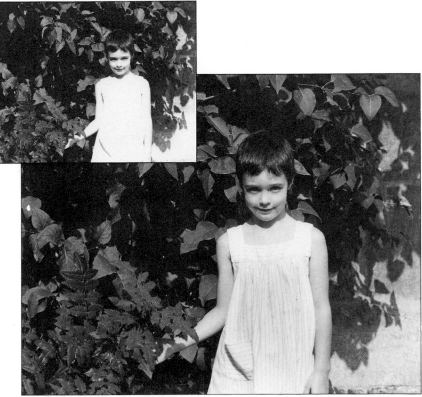

Paper types

Choosing papers involves more than just selecting the most suitable contrast grade for the negative that you are printing. The texture of the paper surface also affects the appearance of the print, as do the base material and the image tone.

Personal preference largely determines your choice of surface and image tone; to help you make up your mind, a photographic dealer can show you samples of the different papers. But there are technical considerations, too. Glossy paper gives the richest black tones, but the shiny surface shows up fingerprints and also tends to obscure the image when it catches the light. Papers with lustrous and mat surfaces don't show fingerprints as obviously; and since these surfaces are not as reflective, you can display prints in less carefully controlled lighting conditions, as shown below. Rough and textured papers can make the photographic image resemble a pencil drawing; they also provide a good bonding surface for retouching or hand-coloring.

Chemical toning can change the color of any paper (see page 94). Alternatively, you can buy ivory-tinted papers as well as papers that give a warm black image without toning, as used for the picture of the girl opposite. Choice of developer can make a warm-toned paper even warmer in hue.

The most popular black-and-white printing paper has a protective coating of plastic that reduces absorption of water and chemicals, thus cutting processing and drying time. However, as an alternative to this resin-coated material, you can buy fiber-based paper, which has a light-sensitive coating applied directly to the paper surface. Although fiber-based paper needs particularly careful processing, it has certain advantages, as explained on the opposite page. Which of the two types you choose depends on how you plan to process your pictures and what you want to do with the finished prints.

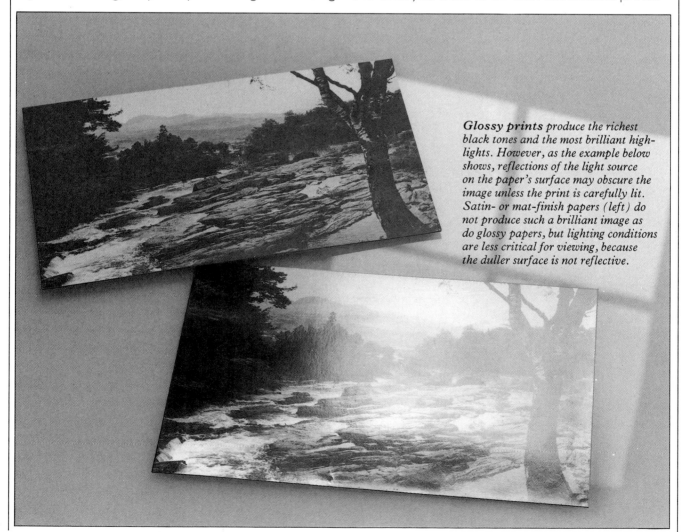

Glossy prints produce the richest black tones and the most brilliant highlights. However, as the example below shows, reflections of the light source on the paper's surface may obscure the image unless the print is carefully lit. Satin- or mat-finish papers (left) do not produce such a brilliant image as do glossy papers, but lighting conditions are less critical for viewing, because the duller surface is not reflective.

Fiber-based paper

Although paper coated with resin, called RC paper, saves time in the darkroom, many photographers prefer to use the more traditional fiber-based paper – principally because it tends to be more stable if it is properly processed and stored, and because it is often thought to give richer tones. You can also mark the reverse of a fiber-based print using conventional inks, whereas you need special quick-drying inks to rubber-stamp or write on the back of regular paper. However, fiber-based paper absorbs water and chemicals, and this prolongs the processing cycle, as outlined below. Fiber-based prints dry more slowly too, and may wrinkle and curl up if allowed to dry naturally.

Processing cycles

Fiber-based paper	Resin-coated paper
1 – Developer for up to 3 minutes	1 – Developer for about 1½ minutes
2 – Stop bath for 30 seconds	2 – Stop bath for 15 seconds
3 – Fixer for 8 minutes	3 – Fixer for 2 minutes
4 – Rinse for 30 seconds	
5 – Hypo clearing agent (an extra chemical bath that helps remove remaining fixer which might cause deterioration)	
6 – Wash for 10 minutes (or longer if the paper is a heavy grade)	4 – Wash for 4 minutes
7 – Drying for up to several hours in a warm room	5 – Drying generally for 30 minutes or less in a warm room

Paper structure

All printing papers have a basically similar structure. But as the diagrams below show, fiber-based paper does not have plastic coatings on either side of the paper base. To make the print more brilliant, fiber-based papers have a white interlayer on top of the base; in resin-coated papers, white pigment in the upper plastic layer provides the brilliance.

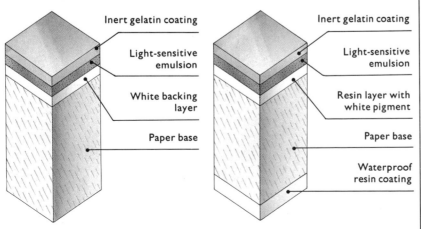

Fiber-based paper

- Inert gelatin coating
- Light-sensitive emulsion
- White backing layer
- Paper base

Resin-coated paper

- Inert gelatin coating
- Light-sensitive emulsion
- Resin layer with white pigment
- Paper base
- Waterproof resin coating

Warm image tones can be created by changing paper, as the picture below shows. This image was printed on a warm-toned paper, whereas the portrait at the bottom of the page was made on regular paper. The brownish tint of a warm-toned paper, such as Kodak Ektalure, can be enhanced by processing the paper in Selectol developer.

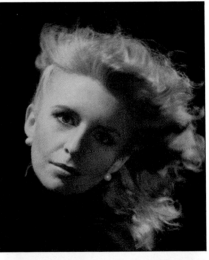

Basic control techniques

By using special control methods during enlarging, you can improve the overall appearance of prints and make good pictures into excellent ones. The two main techniques of control involve reducing or increasing exposure for selected areas of the print so as to achieve a correct overall density and avoid having some areas too dark and others too light.

In dodging (left-hand diagrams below), you shade areas of the printing paper during exposure so that they receive less light than the rest of the image and print lighter than they would during a uniform exposure. As a result, dodging can reveal detail in shadow areas that would be too dark in an otherwise correctly exposed print.

Burning-in, also known as printing-in (right-hand diagrams below), is the exact opposite of dodging. Areas that are too light in relation to the rest of the picture get extra exposure so that they print darker. Whereas dodging is done during the main exposure, burning-in requires a second exposure with all but the selected areas shaded from the light.

To use either technique effectively, you need to know how much lighter or darker a particular area should be. The surest way to calculate this is to make a test strip that includes the full range of tones in the subject, as illustrated on the opposite page. The test strip will show the best exposure time for the main part of the image, and also indicate how many seconds more or less you need to expose areas that are too light or too dark.

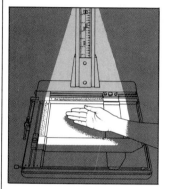

Dodging with a hand
Use your hand to dodge, or hold back light, in large areas of a print. Position your hand to the size and shape of the area to be shaded, and move it to and fro continuously to avoid an abrupt change of tone in the print.

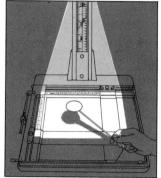

Dodging with a tool
Use a dodging implement (see below) of a suitable size and shape to shade small or isolated areas. Keep the tool moving from side to side all the time during exposure, so that you do not get obvious edges where the shadow falls.

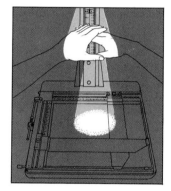

Burning-in with cupped hands
Cup your hands over the paper around the area of the print that you wish to burn-in (give extra exposure to). By moving your hands closer together or farther apart, you can reduce or increase the part of the picture you burn-in.

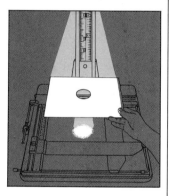

Burning-in with a card
Use a sheet of cardboard with a hole cut out to burn-in a small area of a print that needs darkening. Again, keep the card moving across the area during the additional exposure to avoid leaving discernible edges.

Equipment for dodging and burning-in
Dodging tools and burning-in cards (right) can be made very simply at home by using squares of cardboard and fairly stiff wire. For burning-in, cut out holes of different shapes and sizes in the cardboard. The cut-out pieces can then be glued or taped to lengths of wire to make dodging tools. Do not try to make the edges of the shapes too symmetrical: generally rounded or serrated edges will be best, because any shadow lines around the burnt-in or dodged area will be less noticeable. To avoid light from the enlarger reflecting back onto the printing paper, use black cardboard; alternatively, paint the cardboard black or cover it with black tape. Supplement a selection of different cards and tools by using your hands for larger areas.

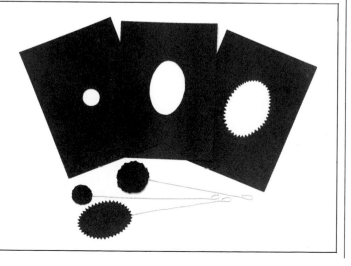

Burning-in a print

A test strip of the scene below revealed extremes of
light and dark. A print made at two seconds' exposure
clearly showed the backstage figures and details of
the audience. But the figures on the stage were much
too light. At 16 seconds, the stage figures printed
correctly, but detail was lost in the darker areas. The
final print was made by exposing for two seconds, then
burning-in the highlights for 14 seconds.

64 seconds 32 seconds 16 seconds 8 seconds 4 seconds 2 seconds I second

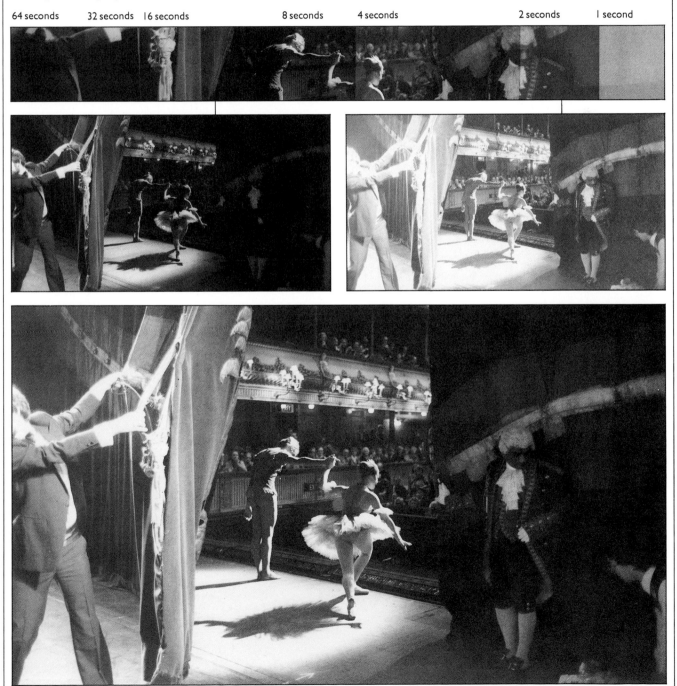

Combination printing

By printing two or more negatives consecutively onto a single sheet of paper, you can create a completely new image. This kind of combination printing allows you to construct scenes with convincing realism or make intriguing juxtapositions to suggest the fantastic. The diagrams below show how easily you can combine two different images to make a stronger, natural-looking composite.

Good results depend on a careful prior assessment of the images you wish to combine. Look for negatives that work together and also suggest similar lighting conditions. Then consider which areas of each image you need to lose to make way for new subject matter. If the unwanted areas are dense in the negative, fade them out by dodging during exposure, using your hands or a dodging tool. In fact almost all combination printing involves some degree of dodging unless you have two negatives of the same size, each with a broad clear area in the opposite halves of the scene. In this case, simply sandwich the negatives together in the carrier and print them simultaneously.

Once you master the technique of making combination prints with two negatives, you can go on to experiment with three, four or even more. Some photographers take pictures of particular subjects especially for use in combination printing. For example, pictures of clouds and the moon are useful for printing onto landscapes weakened by pale, featureless skies.

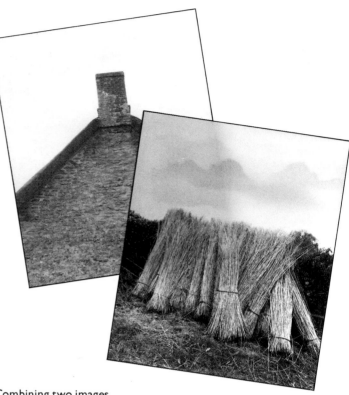

Combining two images
The two prints shown above are typical examples of subjects that can be successfully combined. The content of each picture is quite simple, and the image of the sheaves has an area of blank space in the sky. The two images were printed consecutively onto a single sheet of paper, following the steps diagrammed below, to make the fascinating combined image on the opposite page.

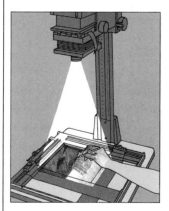

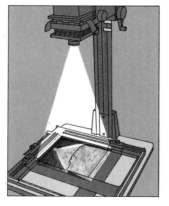

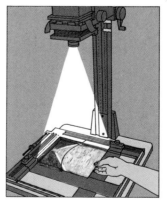

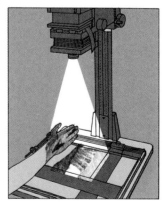

1 – Put the negative with the largest blank space in the enlarger and focus on a sheet of white paper on the easel. Sketch in the outline of the projected image. Replace the sketch with printing paper and make a test strip from the negative to determine the correct exposure. Mark the enlarger head position.

2 – Replace the first negative with the second, and put the sketch on the easel. Adjust the enlarger head to compose the second image in the blank space shown on the sketch. Remove the sketch and make another test strip. Mark the new position of the enlarger so that you can easily make another print if necessary.

3 – Print the second negative onto a sheet of paper. Use a dodging tool or your hand to shade all areas that overlap areas you want from the first negative. Mark a corner of the paper so that you can put it back on the easel in the same position, and place the paper in a light-tight box. Remove the negative.

4 – Put the first negative back in the enlarger. Adjust the head to the position you marked at step 1. Use the sketch to help you recompose the image. Return the exposed paper to its original place on the easel, and print the first negative. If the blank space is dense, dodge during exposure to stop darkening.

Vignetting

Vignetting is a printmaking technique by which you fade off the edges of an image to white or black. Although traditionally used to give a graceful oval border to a portrait, vignetting can be extremely effective with a wide variety of other subjects: for example, you can use it to eliminate a distracting background or to isolate one part of a picture to produce a more arresting image.

To make a white vignette, such as the one illustrated below, you need to mask the outer parts of the image while making the exposure. The simplest way to do this is to project the image from the negative through a hole in a piece of cardboard. Cut the hole in the cardboard the same shape as the area you want to print. Estimate the size of hole that will give you the desired effect when you hold the cardboard about halfway between the enlarger lens and the paper. While making the enlargement, keep the cardboard moving to soften the edge of the image; another way to achieve gradual fading is to rough-

cut the edges of the hole. Alternatively, to create an abrupt contrast between the image and its surrounding area, make your hole clean-edged and hold the cardboard still during exposure.

A black vignette, as shown on the opposite page, is no more difficult to create than a white one. First, expose the negative normally and then remove it from the negative carrier. Select or fashion a dodging tool in the shape you want the image to be. Hold the dodging tool above the enlarging easel, between the paper and the enlarging lens. By turning on the enlarger lamp, you can then fog the printing paper all around the area shadowed by the dodging tool. Unless you want a clean-edged vignette, keep the dodging tool continuously in motion to soften the transition from the image to the black area that the extra exposure produces. An exposure time equal to that of the original negative exposure should be enough to give a dense black area around the image, as achieved opposite.

A sailing ship looks authentically antique in a print vignetted to white (above left). The photographer jiggled a piece of cardboard with a hole cut in it above the printing paper during exposure, as diagrammed above. As well as giving a period flavor, vignetting minimized the tilted horizon and blurred two distant ships. Compare this with the image (top) in a print taken from the whole negative.

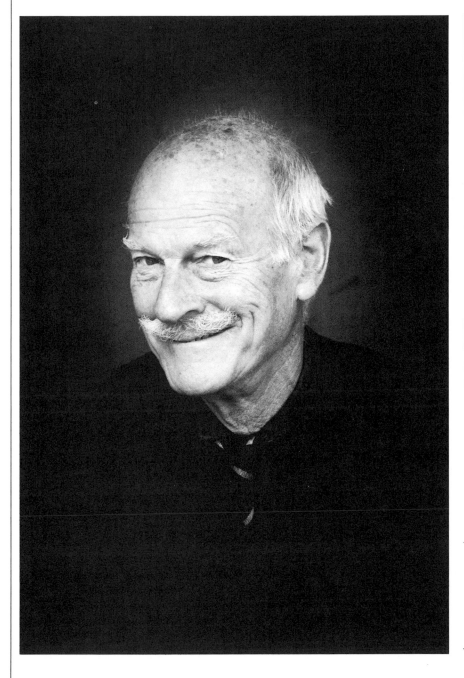

A portrait of British photographer Norman Parkinson, his face lit by a mischievous smile, was an ideal basis for an oval vignette surrounded by black (left). In a print from the whole area of negative (top), the austere background was unflattering. By vignetting with an oval dodging tool as diagrammed above, the photographer emphasized the expressive face and thereby achieved a much more professional and eye-catching finish to the print.

Simple special effects

You can produce unusual effects by using various special techniques in your printmaking.

The simplest and most direct of these techniques does not require a negative at all. To make a photogram, as shown below at left, you need only place objects on the paper before exposing and printing in the normal way. Alternatively, put smaller objects into the negative carrier itself. The shadows cast on the paper by opaque objects make high-contrast prints, with the shapes of the objects printing as bright white. Translucent objects such as leaves give varied tones, and you can experiment with the density and contrast of the image by making a test strip, just as you would with a negative.

Texture screens enable you to overlay normal prints with patterns. You can buy these screens or make your own by using netting, textured glass or plastic, or translucent materials such as tissues and tracing paper. One way to use texture screens is to place the screen over the printing paper. You can also place the screen next to the negative in the carrier and project both images simultaneously, or project first the negative alone and then the screen alone onto a single sheet of paper. When using texture screens, print several versions, varying the pattern size, to be sure of a satisfying result.

By tilting the enlarger's easel, you can distort part of the image during printing to create fascinating or dramatic effects, as on the opposite page. The same technique can correct unwanted image distortions, such as converging verticals in buildings that result from pointing the camera upward.

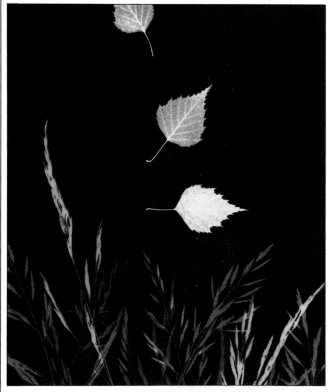

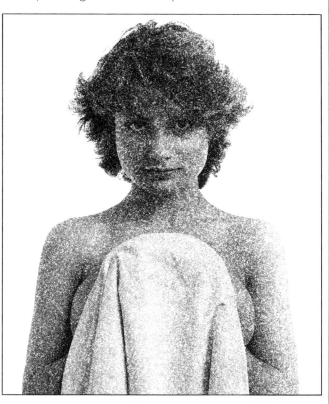

Making a photogram
A photogram from leaves (above) was made by laying the leaves on the printing paper beneath the enlarger (right), then flattening them with a sheet of glass and focusing with the lens set at a small aperture to ensure sharp outlines. Because no negative is used, the tones in a photogram are reversed.

Texturing a print
A screen of textured glass placed directly over the paper (right) gave an attractive mottled effect to the print above. An alternative method, in which you put small pieces of fabric or paper screens in the negative carrier, allows you to create a more open or irregular type of pattern.

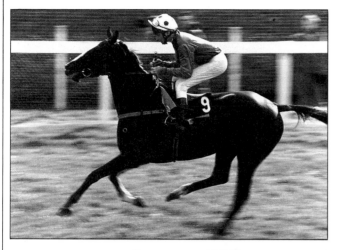

Distorting a print

A normal print (left) of a galloping horse is good but lacks drama. Tilting the enlarging easel (right) during printing stretched the section of the subject projected onto the part of the paper farthest from the enlarger lens and compressed the part nearest the lens. The resulting print, below, is much more exciting. With this technique, tilt the enlarger head until the whole scene is in focus (as here) or set a very small aperture.

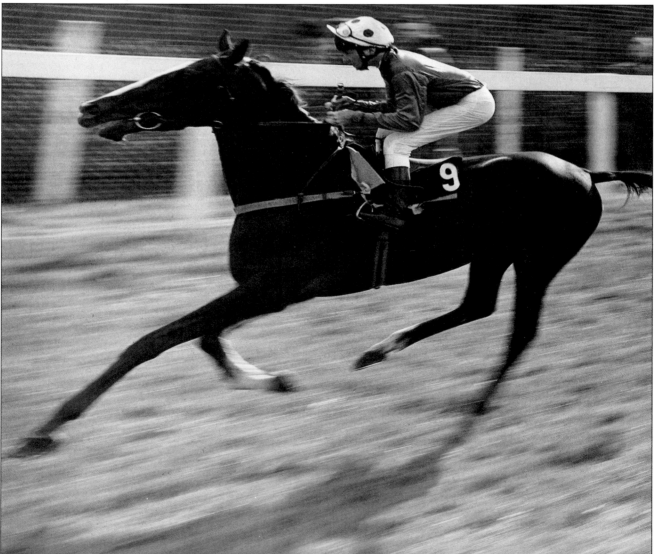

THE COLOR DARKROOM

Processing and printing in color generally involve more steps than in black-and-white, and accuracy in timing and temperature is more crucial. But even if you go directly to color darkroom work, the techniques are not difficult to master provided you concentrate on what you are doing, follow manufacturers' instructions exactly and carry out procedures in the same way each time so that you can control the variables.

The following pages explain all the steps involved in color processing and printing, from developing negatives or slides to producing prints. This basic knowledge is useful whether or not you use the faster methods that manufacturers are introducing. Tips on how to identify and correct faults at each stage help you to improve your techniques in achieving a final, balanced image.

Some people who enjoy color printmaking prefer to have their film processed by a commercial laboratory. However, home processing can provide valuable insights for both picture taking and printmaking. The dimension of color makes the printmaking side of the color darkroom particularly exciting. You can not only ensure realistic colors in your prints but you can also gain the freedom to experiment with all kinds of creative changes and imaginative color effects, as the following pages show.

A color negative, correctly exposed and developed, is projected onto the enlarging easel for focusing. Items to the right of the masking frame are a magnifying glass to aid focusing, a brush to clean the negative carrier, and strips of negatives in a protective plastic sleeve.

The three-color system

To understand the process of color printing, it helps to look briefly at how color film forms a negative image, and how printing translates this into a positive picture with lifelike colors.

Color film is sensitive to the three primary colors of light – blue, green and red – which, mixed together, can make up all other hues. When you take a picture, three light-sensitive layers of emulsion, coated one on top of another, each record one primary color separately. The top layer makes a record of blue light and, after processing, yellow dyes appear in this layer as a negative image, yellow being the complementary of blue. Lower layers make similar "opposite" dye images of the two other primary colors of light. Green light forms a magenta image in the middle layer, and red light records as a cyan image in the lowest layer.

The next stage – printing the negative – is similar in principle to the exposure of film in the camera. Again, the material exposed has three light-sensitive layers, this time coated onto a white paper base instead of onto clear film. By projecting your color negative onto the paper, and then processing the sheet, you reverse the tones and hues back again to make a negative of a negative – a positive print that restores the original colors of the scene or subject you photographed.

To fine-tune the colors of your print, you must use colored filters when exposing the paper. And because printing reverses the hues of the negative to make a positive image, filtration, too, must work in a back-to-front manner. This takes a little getting used to. For example, placing a yellow filter in the light-path of the enlarger does not make the print yellower. Instead, it takes the yellow *out of* the picture. Subtracting yellow is the same as adding its complementary – blue. Thus, adding yellow to the filter pack makes your prints bluer.

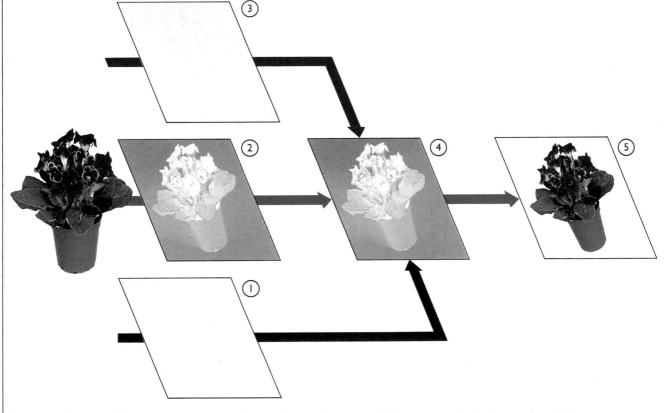

From negative to positive
The diagram above shows three coatings of light-sensitive emulsion in a color negative, each recording a different color. The top layer (1), sensitive to blue light only, records just the blue pot and white background (which reflects all colors). This layer appears yellow – the complementary of blue – after processing. The film's second layer (2) records just the green in the scene – the leaves, and the green component of light in the background and pot – and turns magenta (a purplish pink) during processing. The film's bottom layer (3) records red light from the flowers and the background – and forms a cyan (greenish blue) image. The dyes in these three negative layers are actually superimposed on the film, and an orange masking layer partly conceals the color differences (4). Printing the negative returns all the hues in the image to normal (5).

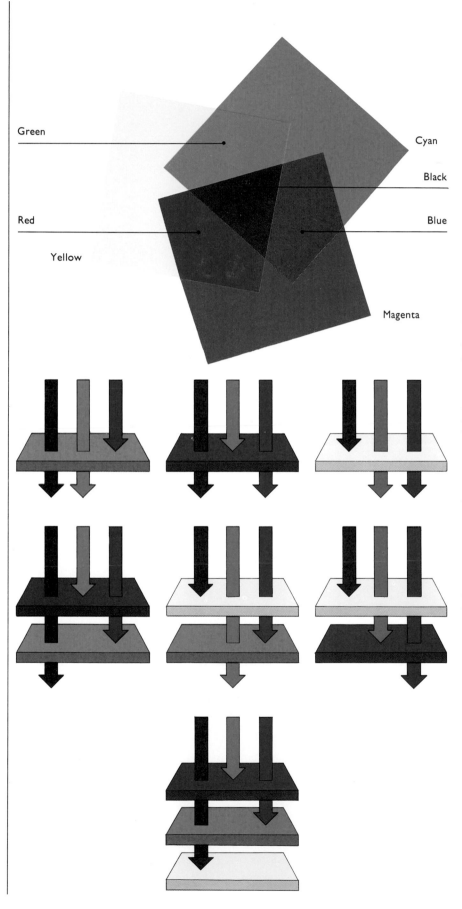

Green

Cyan

Black

Red

Blue

Yellow

Magenta

Color filters
Combined in equal strengths, the three filters used in color printing absorb all colors of light, producing black. But mixed in varying proportions, they can produce nearly any color in the spectrum.

How filtration works
Printing filters have the same colors as the dyes in the three emulsion layers of the negative – yellow, cyan and magenta. These are called subtractive colors because each one absorbs, or subtracts, its complementary from the three primary colors – red, green and blue. The two other primary colors pass through the filter. Where two filters overlap, only one of the primary colors passes through; and overlapping three filters of equal intensity eliminates color altogether, creating gray or black, as shown above. Using combinations of these three filters, in a variety of strengths, you can change the color of the enlarger light – and thus the overall color of the print.

Processing color negatives/1

You can process most kinds of color negative film in a home darkroom without much expense or difficulty, although there are some types that must be sent to a laboratory for processing.

If you already have all the equipment for processing black-and-white film, you are well set up for color and will require only a few additional items such as a high-temperature darkroom thermometer marked in 0.5°F (0.3°C) divisions, and a couple of extra graduates and storage bottles for mixing and storing solutions.

Chemicals for processing color film come in kit form. Be sure to buy a kit containing chemicals compatible with the film you use – a Kodak C-41 kit will process Kodacolor and most other color negative films. Some kits can be used for processing color prints as well as color negatives.

When preparing chemicals for processing, always follow the manufacturer's instructions with the utmost accuracy. Store any leftover or reusable solutions in tightly stopped bottles. The bleach used in color processing lasts indefinitely, but the useful life of other solutions is limited: developer usually keeps for about six weeks, fixer and stabilizer for about eight weeks. Always label all storage bottles clearly, indicating solution type and expiration date.

To prevent skin irritation, wear rubber gloves whenever you are preparing or using color processing solutions; wash the gloves before you take them off at the end of session. Try to avoid splashes, and if you do spill chemicals, rinse them away as soon as you can. To stop staining on enamelled and porcelain sinks, wash them down frequently with fresh water. The chemicals involved in color processing are all more corrosive than those used for black-and-white.

Temperatures for processing color negative film are higher, and more critical, than for black-and-white film. For example, Kodak Flexicolor chemicals work at 100°F (37.8°C), and you must maintain the developer within an average of $\frac{1}{4}$°F (0.15°C) of this level throughout development. Usually, you can allow the other solutions and the wash water to vary within a wider range – 75°F to 105°F (24–40°C). The box below describes alternative ways to maintain the correct temperature during processing. Some kits are designed for lower temperatures, which makes them easier to use, although processing times are correspondingly longer.

Timing is also a critical factor. Control the time allowed for each processing stage by one of the methods described at the top of the opposite page. Note that the time of each step (given overleaf) includes the time it takes you to drain the developing tank. This is usually about 10 seconds. Have a few practice runs first, and always start draining the tank so that it empties precisely on schedule.

Controlling the temperature
To maintain all the processing solutions at the recommended temperatures for the kit in use, put them in graduates or beakers in a deep bowl filled with warm water, as shown at right. Before using a solution, check its temperature and if necessary add hot or cold water to the water bath to bring it to the correct warmth. Wash the thermometer after checking each solution.

If you want infallible temperature regulation, invest in a thermostatically controlled unit of the kind illustrated at right.

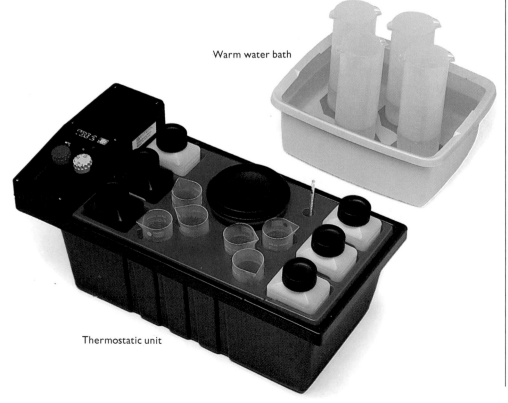

Warm water bath

Thermostatic unit

Electronic timer

Tape recorder

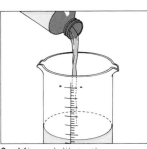

Clockwork timers

Controlling the time

A clock with a sweep hand is sufficient to time the various stages of color processing. However, you may prefer to buy a special darkroom timer, which you can set to make an audible signal when the required period has elapsed. Clockwork timers are the cheapest. One popular model, shown directly at left, has three projecting buttons. Pressing the green button starts the hands moving to indicate elapsed time. The red button stops the clock at the end of each processing step, and the black button sets the hands back to zero.

Another type of clockwork timer (shown at far left) has a dial into which you insert small stop pegs at preselected intervals. When the first peg turns against a special feeler, a bell rings and the clock stops. Electronic timers, as shown at left, above, are also available. Some types can be operated by a foot switch.

An alternative timing method is to make a tape-recording of yourself speaking the processing instructions at precisely timed intervals.

Equipment checklist
Developing tank and reel
Warm water bath or
 thermostatic unit
Clock or timer
High-temperature darkroom
 thermometer
Graduates
Storage bottles
Funnel for filling bottles
Clothespin or film clip
Rubber gloves

Optional equipment
Light-tight changing bag
Soft sponge
Water filter
Hose

Materials checklist
Kodak Flexicolor processing kit
 (Process C-41) or similar

Preparing to process

Give yourself plenty of time to process color negative film. Loading the film into the developing tank, mixing the chemicals and bringing them to the right temperature, as described below, should take about half an hour. With most kits, you need to allow about half an hour for the processing itself, excluding drying time.

1 – Load the exposed film into the developing tank in total darkness. The procedure for this is exactly the same as for black-and-white processing. If you think your darkroom may have a light leak, use a light-tight changing bag. Make sure that your hands are clean and dry. Handle the film only by its edges.

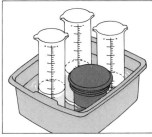

2 – Mix and dilute the chemicals to the working strengths recommended in the manufacturer's instructions. Take care to avoid the slightest contamination of one chemical by another. One way to ensure this is to use a separate graduate for measuring out each of the chemical solutions.

3 – Stand the graduates and developing tank in a warm water bath. Start with the bath at a higher temperature than you need, and let the developer cool slowly. When the solution is still about 1°F too high, begin processing so that the temperature reaches the correct level mid-way through.

Processing color negatives/2

The processing stages for color negatives vary in number according to the kit you are using. For example, the Kodak Flexicolor processing kit has seven steps including drying, as shown in the table on the opposite page at top left.

Once you have loaded the exposed film into the developing tank, mixed all the solutions, and brought both the tank and the solutions to the correct temperature, you can start processing. The boxed text on the opposite page at far right, below, describes, in simplified form, the chemical principles underlying each stage. But you need not understand the precise chemistry to produce excellent negatives.

A meticulous approach to timing, temperature control and agitation is a prime requirement in color processing, particularly during the critical developer stage. As when mixing, follow the manufacturer's instructions with care and avoid contaminating any chemical solution with any other solution. Carry out the washing stages thoroughly, with warm water as explained in the box on the opposite page at top right.

You can agitate your film by inverting the developing tank, rotating the tank or rotating the reel within the tank. The method you use will depend on the design of your tank. To ensure consistently good results, remember to use the same method each time you process; the sooner it becomes a habit, the better.

The step-by-step instructions given below apply to the seven-stage Process C-41. Other processes differ from this in detail, but the general procedure is essentially similar.

Processing the negative

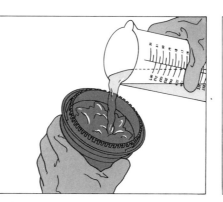

1 – Check the temperature of the developer. If necessary, adjust it to the correct level by adding hot or cold water to the warm water bath. Remove the developer from the bath.

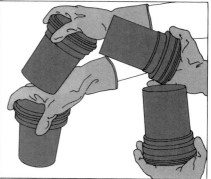

2 – Pour the developer into the developing tank. Tap the tank sharply on the work surface to remove any air bubbles from the film. Then start the timer (or note the time on the clock).

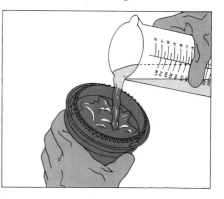

3 – Agitate the tank. After an initial agitation that begins the process, you generally need to agitate at regular intervals, following manufacturer's instructions about timing.

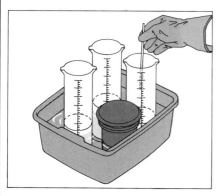

6 – Empty the tank at the end of the bleach step. Timing is not as critical as for development, but the duration of this step should not fall short of the specified period.

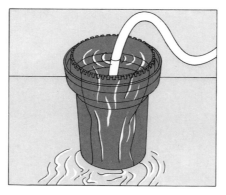

7 – Wash the film in running water, or else use several changes of water, agitating constantly. You can take the lid off the tank at this stage if this makes washing easier.

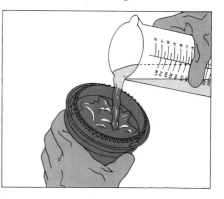

8 – Pour in the fixer, reset the timer, and agitate as directed until the film has been fixed for at least the time specified. Then drain the tank, and wash the film as in step 7.

The Kodak Flexicolor processing kit

The table below breaks down the stages in the processing of color negative film, using Process C-41. The time for each step includes a drain time of 10 seconds. If you reuse solutions, extend the times as recommended in the manufacturer's instructions included with the kit.

Processing step	Minutes
1 Developer	$3\frac{1}{4}$
2 Bleach	$6\frac{1}{2}$
Remaining steps in normal room light	
3 Wash	$3\frac{1}{4}$
4 Fixer	$6\frac{1}{2}$
5 Wash	$3\frac{1}{4}$
6 Stabilizer	$1\frac{1}{2}$
7 Drying	10–20

Washing the film

One way to wash the film after the bleach and fixer stages is to fill the tank with warm water, agitate vigorously, then repeat the operation six times. However, a better method is to use a hose attached to a faucet. Push the nozzle of the hose down the center of the reel (cross-section, right) and turn on the faucet. Use a water filter on your faucet to remove any impurities.

Washing times depend on the temperature of the water. A wash at 95°F (35°C) needs only five minutes, while 69°F (20°C) – the lowest you should allow the water temperature to fall – requires at least 15 minutes.

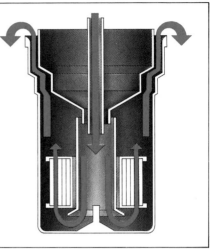

4 – Leave the tank in the water bath when you are not agitating it to maintain the solutions at the correct temperature. Do this after each agitation step throughout the process.

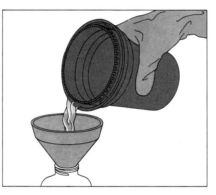

5 – Drain the tank after the alloted time, pouring reusable developer into a bottle. Quickly refill the tank with bleach and reset the timer, then agitate according to the instructions.

What happens during processing

When you take a picture, light reaches silver halide crystals in the emulsion and creates minute specks of silver that form latent images in each of the three emulsion layers. As in black-and-white processing, developer turns these light-struck crystals black. At the same time, the by-products of development combine with chemicals in the film to form color dyes varying in placement and strength according to the pattern and density of silver grains in the three layers.

After development, the next step is to remove the silver grains by means of a bleach bath that reconverts them to silver halide crystals but leaves the dyes in place. Then you add a fixing solution. This removes all silver crystals and thus stabilizes the image so that light cannot fog it. Some processing kits have a combined bleach and fixer, known as a blix. The final stage of processing is to make the image stable, either by washing the negative to remove residue chemicals or by adding a stabilizing solution.

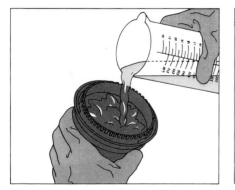

9 – Pour in the stabilizer. With kits that omit this stage, rinse the film in water treated with a wetting agent; but do not rinse film that you have stabilized. Remove the film from the reel.

10 – Hang the film up to dry in a warm, dust-free room, using a film clip or clothespin. To stop the film from curling, you can attach another clip or pin to the bottom end.

Understanding color negatives

Because the colors as well as the tones are reversed, color negatives are somewhat harder to judge than are black-and-white negatives, although processing faults often have the same causes. The illustration below shows what a correctly exposed and developed negative should look like. When you begin color darkroom work, you will find it useful to keep such a negative – one that you know has produced good prints – to compare with negatives you are about to print. You can then more readily spot any defects. Some of the most common negative processing faults made by beginners are shown on the opposite page. Almost always, imperfect negatives result from insufficient care in picture taking or processing, and once you can identify accurately the cause of a fault you can easily avoid repeating it.

Always wait until the film is completely dry before examining the negatives. When you do look at them, the first thing you will notice is an overall color mask of light orange. Although this may look like a fault, it is simply built in by film manufacturers to improve color quality on the final print. To some extent, the orange mask conceals the fact that the colors of the original scene are reversed in the negative, red appearing as its complementary, cyan; blue as yellow; and green as magenta. These colors will reverse again to those of the original image when you print the negatives.

Processed color film is easily damaged, especially when still wet. Always handle the film by the edges; finger marks will spoil the negatives. When the film is dry, cut the negatives into strips and store them in a negative filing sheet to protect them from dust, moisture and scratches.

KODAK VPS 5026

1A 2 2A

A normal color negative
The negative above was correctly exposed and processed. Highlights are dark but not too dense, and both shadow and highlight areas show good detail. Different colors and tones are distinct. The edge markings are clearly visible. With correct color filtration, this negative will yield a print with faithful color reproduction.

Weak shadow areas (left) lacking in color, contrast and detail but with adequate detail in the highlights and middle tones, result from underexposure. The low density of the negative will give a print with black, featureless shadows.

A heavy, dense negative (right) suggests overexposure. The shadow areas show fairly good detail, but the highlights are solid and featureless, with very little distinction between colors and tones. If printed, highlights will bleach out.

A dark contrasty negative (left) points to overdevelopment. The mask may look denser than normal, and there may be a reddish cast. Overlong development, too high a processing temperature or too much agitation could cause these faults.

A pale, flat negative (right), with weak highlights, indicates underdevelopment. Too short a developing time, too low a temperature during processing, insufficient agitation or exhausted chemical solutions are among the most common causes of this problem.

A black-and-white negative (left) that retains the characteristic orange hue of color negative film is the result of processing the film in black-and-white developer. Label all bottles carefully to avoid confusion.

A blue overall stain (right) with the image lacking both contrast and detail, is a symptom of fixer or bleach-fix contamination of the developer solution. Clean the tank, reels, graduates and other processing equipment thoroughly after processing each batch of film.

A positive image (left) with a dark blue cast is the result of processing a color negative film in E6 (color transparency) chemicals. Keep the solutions for the two processes well apart in the darkroom.

An overall green/cyan cast (right) on the negative shows light fogging. Make sure that the darkroom is light-tight, and that the lid of the tank is sealed properly. Fit a protective cover over light switches to prevent them from being switched on inadvertently.

Making a test print

In color printmaking, you control not only the density of the image but also the color balance. As with black-and-white printing, the first step is to make a test print. But because two variables are involved – the exposure time and the color of the exposing light – the procedure differs slightly. To control the color of the light reaching the paper emulsion, you can either adapt a black-and-white enlarger for color with acetate filters, or use a special color head with filtration adjusted by dials, as shown at right. For your test print, select a starting filtration of 50 magenta, 90 yellow and 0 cyan, then adjust this according to the manufacturer's directions on the box of printing paper you are using. Next, expose your test strip, as demonstrated on the opposite page.

Color printing paper is much more sensitive to all the colors of light than is black-and-white paper. For this reason, you must work in total darkness, or use a color safelight, until the paper is sealed in a light-tight processing drum. The safelight must be at least four feet from the paper; do not expose the paper to it for longer than three minutes.

The number of chemical stages in print processing varies from one processing kit to another, but all kits follow approximately the procedure diagrammed in the sequence below. Read the manufacturer's instructions carefully. Both when exposing and processing, make sure you follow exactly the same procedures every time. Take particular care over the temperatures of solutions and the timing of each stage. Remember to note down the details of each step – exposure time, filtration used, processing times and temperatures – so that you can repeat or modify your results after assessing the test print.

Equipment checklist

Enlarger with wired-in voltage regulator
Color printing filters or color head
Enlarging easel
Soft brush and compressed air can
Cardboard mask
Print-processing drum
Timer
High-accuracy darkroom thermometer

Bucket for presoak water
Water bath
Graduates
Bottles for made-up solutions
Rubber gloves
Soft sponge

Materials checklist

Kodak Ektaprint 2 processing kit or similar
Color printing paper

Color filtration systems

A color head has built-in filtration that you can control by dials (shown at right). Acetate color printing filters (see below) are placed in the filter drawer of a basic enlarger. Filter kits contain cyan, yellow and magenta filters of varying densities, from five to 80. The filters are stacked together to make up the color and density values of the required filtration. Usually, a CP2B filter is included to filter ultraviolet radiation.

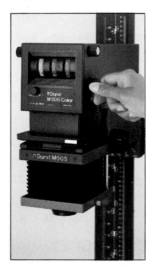

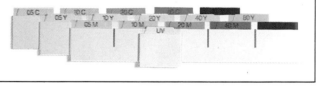

Processing a color reversal print

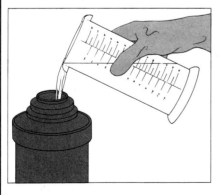

I – Fill the processing drum with presoak water at the correct temperature, as instructed on the processing kit. Set the timer and agitate for the required length of time, then drain the drum.

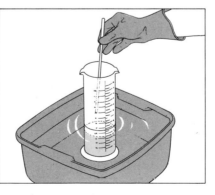

2 – Place the first developer solution in a water bath to bring it to the right temperature. Test with a high-accuracy thermometer. Pour the solution into the processing drum and set the timer.

3 – Agitate the drum by rolling it back and forth on the work surface, or use a motorized roller. Agitate 30 to 60 times a minute, or as instructed on the kit, and rest the drum between agitations.

Exposing the print

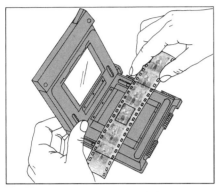

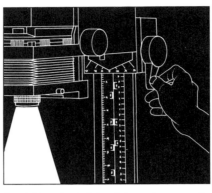

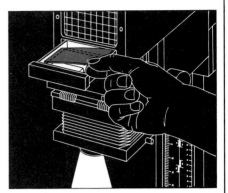

1 – Select a negative that will show up color balance variations: one with flesh tones is ideal. Clean the carrier of dust. Insert the negative.

2 – Adjust the height of the enlarger and position the enlarging easel frame over the test area. Switch off the lights and focus the lens on the test area.

3 – Insert filters, or set the dials on a color head, to obtain the correct value for starting filtration; follow the directions on the printing paper pack.

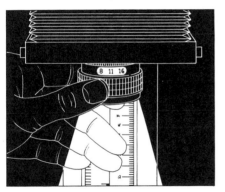

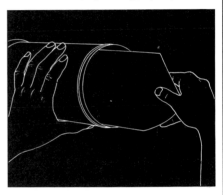

4 – Stop down the enlarger lens to f/11 and switch off the lamp. In the dark or under a color safelight, place a sheet of printing paper in the easel.

5 – Make a test strip using a cardboard mask. Move the mask along every five seconds during a total exposure of 20 seconds, to get four exposure bands.

6 – Place the exposed paper carefully in the print-processing drum, with the emulsion facing inward. Seal the lid of the drum tightly. Turn on the room lights.

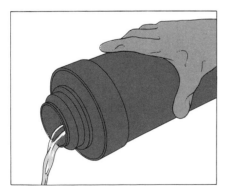

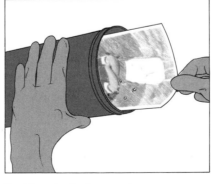

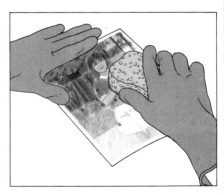

4 – Begin to drain the drum within 10 seconds of the end of developing time. Repeat steps 2, 3, and 4 for each of the remaining processing stages, following the manufacturer's directions precisely.

5 – After the final processing stage, remove the lid of the drum and take out the print, handling it carefully by the edges. Place the print in a tray and wash it thoroughly under running water.

6 – Wipe all the water off the print to prevent spots appearing as it dries. Hang the print up to dry. For more rapid drying, use a hair dryer, but do not let the print get hotter than 200°F (93°C).

Testing filtration

After your test print is dry, you can begin to assess it. The picture may have one or more of the faults shown below, particularly if this is your first attempt at color printing. Use the illustrations to diagnose and correct basic errors of processing technique, then turn your attention to the density and colors achieved in the test print.

One of the strips on your test should be just about the right density. If all the strips are too dark or too light, repeat the exposure test using more or less exposure before making any decisions about changing the filtration.

Unless you are very lucky, your test print will have a color cast. This may be either a pale tint or a strong, saturated hue that suffuses the whole frame. Do not be put off by this; the cast arises because all enlargers have an inherent color bias and a first print seldom has perfect color.

To eliminate the color cast, make a second test, this time to check color. Do so by exposing each quarter of a sheet of printing paper with the enlarger set to a different filtration for each exposure, as explained below at right and diagrammed on the opposite page.

A half-visible image indicates that you rolled the processing drum on a slanted surface, wetting only one end of the print.

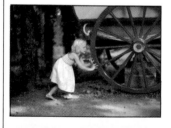

Pink streaks are caused by water inside the drum. Remember to dry it thoroughly each time you make a print.

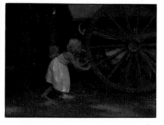

A very dark print with a pronounced color cast shows that you omitted the filters from the enlarger when making the exposure.

A strong magenta cast indicates that you have contaminated the developer with bleach-fix. Wash all graduates thoroughly.

Undeveloped patches on your print indicate that you loaded the paper into the drum with the emulsion side outward, not inward.

Test colors too warm | Test colors too cool
Add yellow — Yellow cast — Subtract magenta
Add yellow and magenta — Red Cast — Green cast — Cyan cast — Subtract yellow and magenta
Add magenta — Magenta cast — Subtract yellow

Adjusting filtration

Before you make your color filtration test, examine the earlier exposure test and decide whether the colors look too warm or too cool. If too warm, make three exposures with added filtration as indicated at the left of the diagram above. If too cool, make subtractions as indicated at the right of the diagram. (A 10-unit change in filtration corrects most pale color casts.)

For example, if filtration for the exposure test is 50Y (yellow), 90M (magenta) and 0C (cyan) and the colors are too warm, try the following changes in filtration for separate quarters of the test sheet:

	first quarter	second quarter	third quarter
Starting filtration	50Y 90M 0C	50Y 90M 0C	50Y 90M 0C
Change	+10Y	+10Y +10M	+10M
New filtration	60Y 90M 0C	60Y 100M 0C	50Y 100M 0C

You can use the fourth quarter of the test sheet either for a more extreme filtration change or for a more moderate change in one filtration density.

None of the filter packs suggested above includes cyan filtration because in printing from color negatives you need use only yellow and magenta filters. To remove a cyan cast from a print, simply reduce the amounts of both magenta and yellow in the filter pack.

Making a color test

Select the part of the exposure test that looks properly exposed – here an area exposed for 10 seconds – and use it as a guide to the color correction needed.

5 seconds 10 seconds 15 seconds 20 seconds

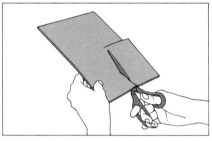

1 – From a piece of cardboard the size of your paper, cut away a quarter so that the cardboard forms an L-shaped mask that covers three-quarters of the paper.

2 – Decide on an initial change of filtration from the one used in the test, and insert the filters or set the dials of the color head. Turn off the room lights.

3 – Take out a sheet of paper and snip off one corner. This will enable you to position the paper in the easel in the same way for each test.

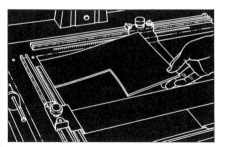

4 – Place the paper in the easel with the cardboard mask in position on top so that one quadrant is uncovered for the first color test.

5 – Expose the first quadrant for the time determined from the exposure test. Replace the paper in its pack and turn on the room lights.

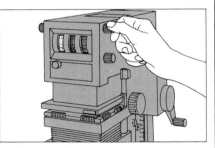

6 – Reset the filtration, then move the easel so that the image area that appeared on the first quadrant falls on a new quadrant. Turn off the lights.

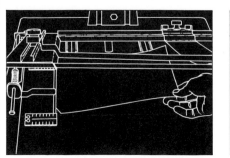

7 – Place the paper back on the easel, and check that the cut corner of the sheet is in the same position as it was for the previous test.

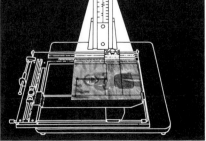

8 – Reposition the mask to uncover the new quadrant, and repeat steps 6, 7 and 8 twice more until you have exposed each quadrant with a different filtration.

9 – Process the paper as you did for the exposure test. Make sure the print is dry before evaluating colors, as hues will look different when the paper is wet.

Making a final print

Your color test will show four different zones, one of which should have more or less correct color balance. On the back of the sheet, jot down the filtration that you used for each quadrant. One or two of the four zones may be lighter than the others. This is quite normal. The cause is the absorption of light by the enlarger's color filters, and when you make the finished print you must make an exposure adjustment, as explained at right, to compensate for the absorbed light.

If none of your tests has perfect color, you will have to make a further filter change. Usually, the required change in the filter pack will be quite small, but this process of fine-tuning the color can actually be more difficult than the earlier correction of heavy color casts. This is because subtle color casts are hard to identify; it is easy to see that there is something wrong, but the remedy is not quite so clear. The ring-around chart on the opposite page will help you to identify an elusive color cast. You may also find it useful to look at the color test through gelatin color-printing filters. Remember that the color of filter that makes the test look right is the one you should remove from the filter pack before making the final print.

Filter factors

Filter value	05	10	20	30	40	50
Yellow	1.0	1.1	1.1	1.1	1.1	1.1
Magenta	1.2	1.3	1.5	1.7	1.9	2.3

When you change filtration, you increase or decrease the amount of light that reaches the negative and the paper; to maintain the print density, you must adjust the exposure time to compensate. If you *add* an extra filter, you should *multiply* the exposure time by the corresponding factor shown in the chart above. And remember to *divide* by the same factor when you *remove* filters from the enlarger.

A color test (below left) shows how changes in filtration affect the print color. The photographer made the final print (below) at the filtration used for the bottom left quadrant but gave extra exposure to compensate for the added filters, as explained above.

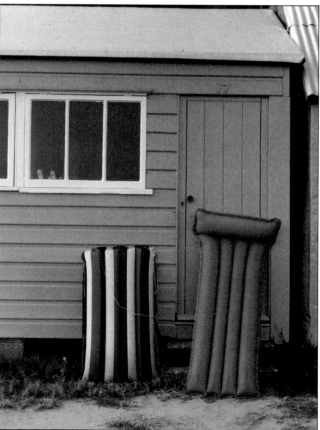

Filter ring-around

If you cannot identify the color cast in your print, try to match it with the color bias of one of the twelve patches on this chart, then note the corrective filtration that you must apply to make a good color print. You may even wish to make your own ring-around instead of using a printed one. Do this by systematically changing filtration between prints, but remember to adjust exposure, as explained in the box on the opposite page.

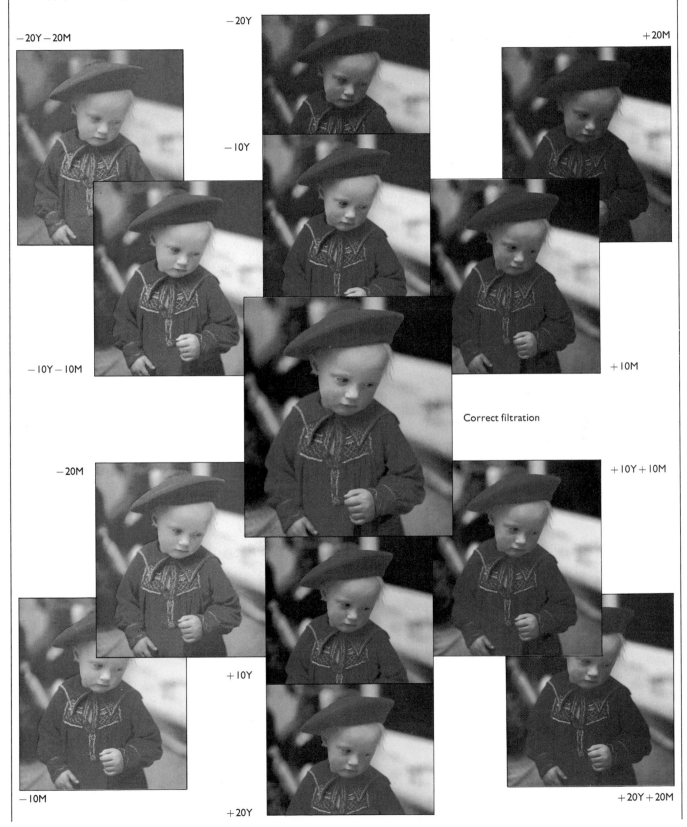

−20Y −20M

−20Y

+20M

−10Y

−10Y −10M

+10M

Correct filtration

−20M

+10Y +10M

−10M

+10Y

+20Y +20M

+20Y

Processing transparencies/1

Color slide film, also known as color reversal film, is almost as simple to process as is color negative film. You can use the same equipment and the same basic techniques. The main difference is that more steps and chemical solutions are involved because reversal film requires two developing stages, with a reversal bath stage in between. The reversal bath causes additional silver to form during the second development. And where this happens, complementary color dyes also form. As the diagrams below show, these dyes reverse the original latent image by forming only in previously unexposed areas where no silver formed during the first development. The subtractive effect of the dyes means that the final positive transparency shows the correct colors of the scene you photographed.

Faulty processing cannot be corrected (unless you plan to make prints from your slides), so timing and temperature control are of the utmost importance. The chart opposite shows the steps, times and temperatures for Process E-6 chemicals, which are suitable for most kinds of color reversal film. Other kits may vary slightly in the number of steps, the temperature range and the time required for processing. Processes are frequently updated, so always check the instructions before you begin.

Whatever process you use, the crucial steps are the first development and the color development. Make up the first developer after mixing all the other solutions, so that you can use it immediately at precisely the temperature indicated. Remember that the color developer may have cooled slightly by the time you are ready to use it: check the temperature again before you pour it into the tank.

First development/reversal
A black-and-white negative image forms where the film's three layers were exposed. After development, a reversal bath chemically exposes the remaining areas.

Color development
The color developer forms metallic silver and color dyes in the newly exposed areas — yellow dye in the blue-sensitive layer, magenta in the green, cyan in the red.

Bleaching and fixing
A bleach bath converts the black silver to soluble silver salts. These are removed in the fixer, so only the color dyes remain. Washing completes the process.

The final transparency
When a transparency is viewed in white light, the complementary dyes subtract primary colors from the light to reproduce all the original colors of the scene.

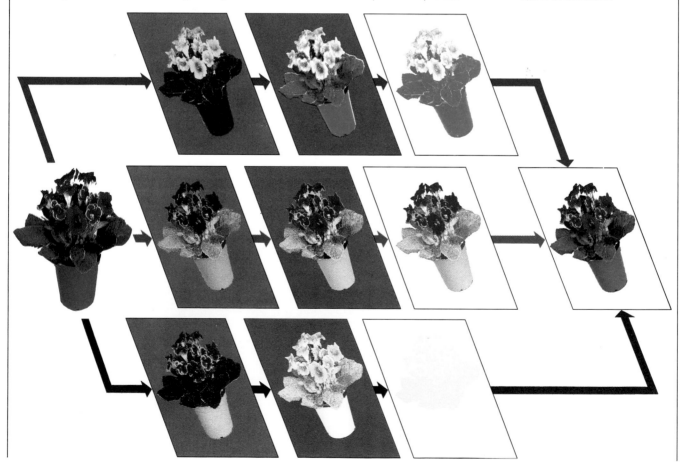

The Kodak Ektachrome Process (E-6)			
Process step	Minutes	°F	°C
1 First dev.	7	100±0.5	37.8±0.3
2 Wash	1	92−102	33.5−39
3 Wash	1	92−102	33.5−39
Or (2,3) wash for 2 minutes in running water			
4 Reversal bath	2	92−102	33.5−39
Steps 5-11 can be done in normal room light			
5 Color dev.	6	100±2	37.8±1.1
6 Conditioner	2	92−102	33.5−39
7 Bleach	7	92−102	33.5−39
8 Fixer	4	92−102	33.5−39
9 Wash	6	92−102	33.5−39
10 Stabilizer	1	92−102	33.5−39
11 Drying	10-20	75−120	24−49

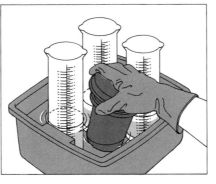

1 – Bring the solutions to the correct temperature. Put the graduates containing the solutions and the loaded developing tank in a water bath at a slightly higher temperature, to allow for cooling.

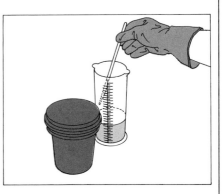

2 – Remove the tank and the graduate containing first developer from the bath. Check the temperature of the developer. If correct, pour the developer into the tank and start the timer.

3 – Agitate as directed. Keep the tank in the water bath between agitations. Pour the developer into a storage bottle during the last 10 seconds of developing time. Rinse the film in the tank under running water.

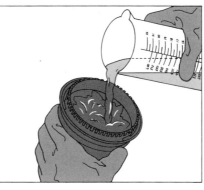

4 – Pour in the reversal bath. Agitate as directed. Check the temperature of the color developer and adjust the temperature of the water bath if necessary. Pour the reversal bath into a storage bottle.

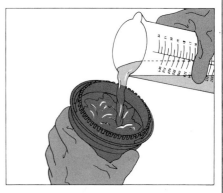

5 – Pour in the color developer. Agitate as directed, checking the temperature at intervals. Keep the tank in the water bath between agitations. Begin draining the tank in the final 10 seconds of developing time as before.

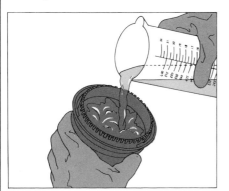

6 – Pour in the stop or conditioner, or wash, depending on the directions. Drain the tank. Pour in the bleach, drain it and pour in the fixer (or pour in the combined bleach-fix, depending on the type of kit). Drain the tank.

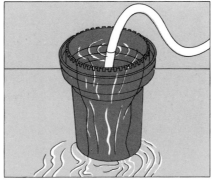

7 – Wash the film in the tank under running water for four to six minutes. (Or fill the tank, agitate, and drain, then repeat with at least five more washes, using fresh water each time.) If the kit includes a stabilizer, pour it in.

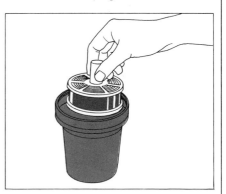

8 – Drain the tank. Remove the lid and lift out the reel, being careful not to touch the film emulsion. Take the film off the reel, handling it by the edges. Hang it up to dry with a film clip on the end to stop curling.

Processing transparencies/2

You can assess transparencies much more easily than color negatives, because transparencies show the final image: the colors are those of the original scene as you photographed it, and there is no orange mask in the film. As with other types of film, poor transparencies are usually the result of insufficient care either in picture-taking or in processing. Some common processing faults are shown below. One point to remember, if you are used to assessing negatives, is that the same fault may produce the opposite appearance in a transparency. For example, an underdeveloped transparency appears too dark, whereas an underdeveloped negative looks too pale. Similarly, touchmarks caused by improper loading of the film onto the developing reel show as clear patches on negatives, but on transparency film they appear dark.

Color casts on transparencies may be caused by chemical contamination or by using a solution that is old, weak or exhausted. Another possibility is that you have not matched the film to the light source. If you used tungsten film in daylight, the transparencies will show a bluish cast; daylight film used in tungsten light will show an orange cast. Always view transparencies against daylight, so that you can assess the color balance accurately.

One advantage of transparency processing is that you can modify the first development time or temperature to compensate for accidentally under-exposing or overexposing a film in the camera, or for deliberately pushing the film speed. The reason you can adjust the processing of transparency film successfully is that the first development affects the contrast and density of the image, but not the color balance. The chart on the opposite page gives recommended first-development compensation for Ektachrome films, using Process E-6. Modified processing gives satisfactory results when the film has been underexposed by one or two stops, or over-exposed by one stop, so that the developing time is not altered drastically. At greater extremes, image quality is likely to be unacceptable. Extreme over-development produces a loss of density, excessive contrast and grain, and a shift in the color balance. Extreme underdevelopment produces a very flat image, again with a color shift.

A dark slide with muddy highlights is underdeveloped. Either the first developer was too cool, or the time too brief, or the color developer was exhausted.

A pale, thin slide may be overdeveloped. The first developer was either too concentrated or contaminated or the development time too long.

An overall blue cast indicates that the fixer contaminated the first developer. Wash the equipment thoroughly after processing each film.

A weak image, with very pale shadows, means that the film was fogged during the first development. Check that the tank is lighttight.

An overall green cast indicates that the reversal bath was exhausted. Check the instructions for details of storage and re-use of the reversal chemicals.

A yellow cast on the high-density areas of the slide, shows that the color developer was contaminated by fixer. Mix a fresh batch of color developer.

A very dark slide with little color may indicate residual black silver. The bleach stage was omitted or inadequate, or the bleach solution was too weak.

Uneven black staining is the result of film surfaces touching during processing. Take care when loading film onto reels, and check that edge-loading reels are dry.

Modifying processing with Process E-6

Film speeds for modifying processing

Kodak film	1 stop overexposed	Normal exposure	1 stop underexposed	2 stops underexposed
Ektachrome 64	32	64	125	250
Ektachrome 200	100	200	400	800
Ektachrome 400	200	400	800	1600
First developer compensation	−2 minutes or −6°F (−3.35°C)		+2 minutes or +8°F (+4.4°C)	+5 minutes or +12°F (+6.65°C)

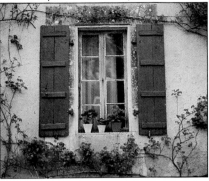

Normal exposure and development

Modifying processing

The images at right demonstrate the effects of different first-development times on transparency film that was wrongly exposed in the camera, or deliberately pushed to cope with problem lighting. The image above at right had normal exposure and development, and serves as an example for comparison. Film underexposed by one stop and given normal development (right) produced an image with overdense colors in the shadow areas. Increasing, or pushing, the first development time by two minutes (far right) produced a near-normal result. Film underexposed by two stops and developed normally (center right) is denser, with poor detail. Increasing the time by five minutes (center, far right) lightened the image, but the colors are more muted, and the contrast and grain are greater than in the normal example. Film overexposed by one stop and then developed for the normal time and temperature (bottom right) gave a pale image with flat highlights. Reducing the development temperature by 6°F (3.35°C) (bottom, far right) improved the image density, but the contrast is lower and there is a slight color shift, most noticeable in the highlight areas. (Note that, for overexposed film, it is preferable to reduce the development temperature rather than the time. Development of less than five minutes is likely to result in streaks and patches on the image.)

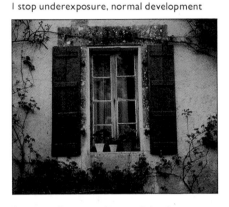

1 stop underexposure, normal development

1 stop underexposure, +30% development

2 stops underexposed, normal development

2 stops underexposed, +80% development

1 stop overexposed, normal development

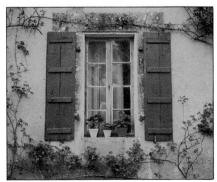

1 stop overexposed, −30% development

Printing from transparencies/1

One way to make a color print from a color transparency is to produce an intermediate negative, or "internegative," and then print this exactly as you would any other color negative. Although you can make your own internegative by photographing the slide using color negative film with a duplicating attachment on your camera, you will usually get more accurate results if you send your slides to a photolab for copying.

Another approach, which is both cheaper and more satisfying, is to make a color print directly from the transparency onto color reversal paper, such as Kodak Ektachrome paper. This gives a positive image from the positive image on the slide. You can use the same equipment as for printing color negatives, but you will need additional filters – printing on color reversal paper often requires cyan filtration, whereas printing on color negative paper requires only magenta and yellow filtration. Filtration assessment is much easier than with negative/positive printing, because you can directly compare the colors of your test strip with the original.

You can easily judge by eye whether a transparency is good enough for printing; thus there is no need to make a contact sheet. Choose an example that is correctly exposed and not too contrasty.

Transparencies have a greater range of brightness than printing paper can reproduce, so a print from a contrasty image would lose details in the highlights and shadows.

Reversal paper reacts differently than negative/positive papers. The image becomes lighter as the paper receives more exposure and darker as the exposure is reduced. The border areas of the print that are masked during exposure will come out black. Since reversal paper is sensitive to all visible colors of the spectrum, you must handle it in total darkness before and during processing.

The procedure for exposing and processing a test strip from a transparency is essentially the same as it is for a color negative. To expose a test strip, follow the diagrams in the upper sequence on the opposite page. For processing, you must be sure to buy chemicals that are compatible with the paper you are using. The processing stages given below are typical, but will vary in details from kit to kit. Follow meticulously the manufacturer's instructions for mixing the chemicals, controlling temperature and time, and agitating the processing drum. Processing is likely to take between 15 and 25 minutes. Usually the temperature is critical for the first developer and color developer, but not for the other stages.

Equipment checklist		
Enlarger with wired-in voltage regulator	Print-processing drum	
Color printing filters or color head	High-accuracy darkroom thermometer	
Enlarging easel	Timer	
Soft brush or can of compressed air	Bucket of presoak water	
Cardboard mask	Water bath	
	Graduates	
	Rubber gloves	
	Print-washing tray	

Soft sponge
Bottles for made-up solutions

Optional equipment
Focus magnifier
Motor-driven agitator

Materials checklist
Color reversal processing kit
Color reversal printing paper
Sheet of exposed, processed printing paper for use when focusing

Processing a color reversal test print

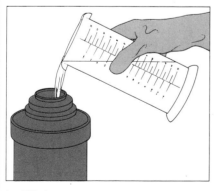

1 – Fill the processing drum with pre-soak water at the correct temperature, as instructed on the processing kit. Set the timer and agitate for the required length of time, then drain the drum.

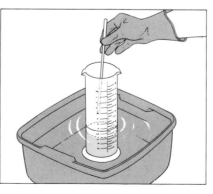

2 – Place the first developer solution in a water bath to bring it to the right temperature. Test with a high-accuracy thermometer. Pour the developer into the processing drum and set the timer.

3 – Agitate the drum by rolling it back and forth on the work surface, or use a motorized roller. Agitate 30 or 60 times a minute, or as instructed on the kit, and rest the drum between agitations.

Exposing a color reversal test print

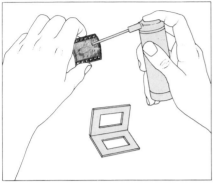

1 – Remove the slide from its mount and clean it using a soft brush or a compressed air jet. Insert the slide in the carrier and place the carrier in the enlarger.

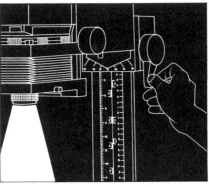

2 – Adjust the enlarger height and place a focusing sheet under the masking frame. Switch off the room light and focus the image. Set the lens at f/8.

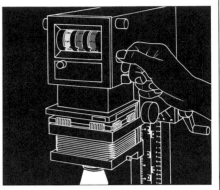

3 – Insert filters, or adjust dials on a color head, to give the correct value for starting filtration (follow the instructions given on the printing paper pack).

4 – With the enlarger lamp switched off, replace the focusing sheet under the masking frame with a sheet of unexposed printing paper, emulsion side up.

5 – Make a test strip using a piece of cardboard as a mask. Move the cardboard along to give four bands, exposed for exactly 2, 4, 8 and 16 seconds.

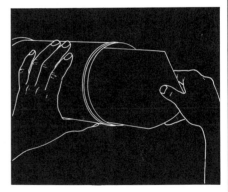

6 – Place the exposed paper in the print-processing drum, with the emulsion facing inward. Seal the lid of the drum tightly to exclude light. Turn on the room light.

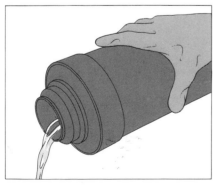

4 – Begin to drain the drum within 10 seconds of the end of developing time. Repeat steps 2, 3 and 4 for each of the remaining processing stages, following the manufacturer's directions precisely.

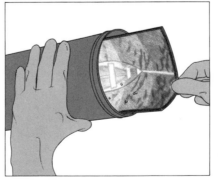

5 – After the final processing stage, remove the lid of the drum and take out the print, handling it carefully by the edges. Place the print in a tray and wash it thoroughly under running water.

6 – Wipe all the water off the print to prevent spots appearing as it drains. Hang the print up to dry. For more rapid drying, use a hairdryer, but do not allow the print to get hotter than 200°F (93°C).

Printing from transparencies/2

After your test print is dry, the first thing to do is examine it for faults. The examples at right (shown for convenience on a properly exposed print) illustrate some of the most frequent errors. To make excellent prints from your transparencies consistently, you must diagnose your mistakes accurately and be sure that they do not recur.

The next step is to examine closely the four exposure bands on your print. Decide which band shows correct tones and make careful note of the exposure time. If all bands are too dark or too light, repeat the exposure test using more or less exposure. As the test strip below shows, reduced exposure results in a darker print, not a lighter one as with color negatives; increased exposure results in a lighter print, not a darker one.

When you are satisfied that one of the bands of your exposure test print is correctly exposed, compare the colors in that band with the colors in the same area on the original slide. Generally, the print will have a color cast caused by the inherent color bias of your enlarger. To eliminate this cast, you must make a second test, this time of filtration. You can make this test by following the procedures described for printing from a color negative, using an L-shaped piece of cardboard to uncover each quarter of the color reversal paper with the enlarger set to a different filtration for each exposure. Alternatively, you can use a quartered masking frame as shown on the opposite page at top right. The filtration adjustments required to correct color balance in prints from transparencies are different from those adopted when printing from color negatives. To compensate for a color bias, subtract filters of the same color or add filters of the other two colors. The principle is illustrated in the box on the opposite page. As a rough instant-filtration guide, you can use a print viewing filter card, as illustrated on the opposite page, below right.

Judging the right exposure

16 seconds 8 seconds 4 seconds 2 seconds

The test strip above was exposed for 2, 4, 8 and 16 seconds at f/8. The 16-second exposure produced the best density but was still slightly too light. Thus for the filtration test, the photographer chose an exposure of 12 seconds.

Common printing faults

A deep orange cast indicates that the paper was fogged before processing by exposure to a safelight. Always handle color reversal paper in total darkness.

A pale print with a color cast may occur if you print without filtration – for example, if you forget to set the filtration after focusing the image.

A weak print with loss of highlights and no shadows occurs when you exceed the first development time, or use first developer at too high a temperature.

Random blotches correspond with undeveloped patches. You probably loaded the paper into the drum with the emulsion on the outside instead of the inside.

Excessive contrast with a blue-black or magenta stain may be caused by contamination of one of the solutions by bleach-fix. Mix a new batch of chemicals, using a separate graduate for each.

A muddy appearance overall indicates that the bleach-fix solution was probably too diluted or exhausted, or that the drain time for the wash preceding the bleach-fix was insufficient.

A band of white is caused by the color developer failing to reach across the print during processing. Check that the drum is on a level work surface.

Choosing filtration

When you are ready to make your filtration tests, first look at your initial exposure test strip and determine whether the correctly exposed band looks too warm or too cool in hue. If it is too warm, make three exposures using the filtration changes indicated on the left-hand side of the color wheel below. If it is too cool, follow the adjustments given on the right-hand side.

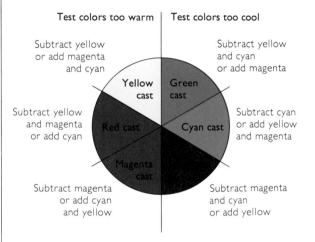

Test colors too warm | Test colors too cool

Subtract yellow or add magenta and cyan — *Yellow cast*

Subtract yellow and cyan or add magenta — *Green cast*

Subtract yellow and magenta or add cyan — *Red cast*

Subtract cyan or add yellow and magenta — *Cyan cast*

Subtract magenta or add cyan and yellow — *Magenta cast*

Subtract magenta and cyan or add yellow

You will need to make greater adjustments than are necessary to correct color casts on prints from color negatives: for a pronounced color cast, a change of 15 units is a good starting point. With practice, you will be able to judge the degree of correction needed by comparing the print with the original slide.

Always subtract filters if you can, rather than add them. This will ensure that there are not more than two filter colors in the enlarger. A combination of three colors would reduce exposure without accomplishing any color correction.

For example, suppose that the filtration for the exposure test was 0Y (yellow), 45M (magenta) and 45C (cyan), and the test came out too cool. The changes needed for the filtration test, as determined from the color wheel above, would be as follows:

	first test	second test	third test
Starting filtration	0Y 45M 45C	0Y 45M 45C	0Y 45M 45C
Change	+15M	0 15C	0 15M0 15C
New filtration	0Y 60M 60C	0Y 45M 30C	0Y 30M 30C

You can use the fourth quarter of your test sheet for a more extreme filtration, or for one that is somewhere between these values.

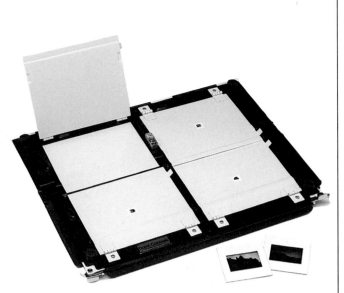

Quartered masking frames

Some masking frames come with four separate hinged, light-tight covers, each of which can mask off a different quarter of the total area of the printing paper, as shown above. This simplifies making an exposure or filtration test. In total darkness you can easily lift one cover before you expose a quarter of the print, then close that cover and lift another one to expose a second quarter, and so on.

Print-viewing filters

Some manufacturers produce color print-viewing filters of the type shown below. These are actual filters mounted in cardboard. Look through the windows to see what your print will look like if you add or subtract a specific filter or pair of filters. By comparing the effect with the original slide you can determine the correct filtration and set the enlarger head accordingly.

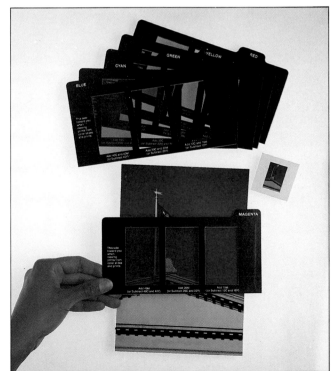

Printing from transparencies/3

A filtration test from a color transparency requires evaluation and interpretation in much the same way as does a test print made from a color negative. But in looking at the four different quadrants from the transparency test, it is much easier to understand the relationship between the color changes and the changes that you made to the filter pack, because there is an exact correlation. For example, putting in extra yellow filtration makes the print yellower – just as putting on yellow-tinted sunglasses makes everything look yellowish.

On the back of the test sheet, make a note of the filtration you used when exposing each individual quadrant. You will probably find that one of the four quadrants has good color, so you can go straight to a final print without making any further tests or changes in filtration. One reason why you can often proceed directly to a successful print is that you probably started with a slide that you knew would print well. (It is easier to recognize and discard a poor transparency than it is to pick out and reject a poor negative.)

Even so, you may find that the best quadrant from your filter test still has a slight color cast. To check this, examine the print in daylight. When deciding what final filtration corrections to make, look especially at light areas and flesh tones, where color casts will be most evident. You may also find it helpful to compare your test print with the ring-around on the opposite page.

Once you have decided on the correct filtration for a particular film type, make a careful note of it together with exposure details. Provided that it does not have a color cast, any other transparency of this film type will print equally well with the same filter pack and exposure setting.

A color test (above) from a transparency clearly shows the effect of changing the filtration. The photographer picked out the quadrant at lower left as best and used the same yellow filtration to make the final print (right). The exposure time was not altered, because the small correction factor – 1.1 – was not enough to make a significant difference to the print density, as explained at right above.

Filter factors

Filter value	05	10	20	30	40	50
Yellow	1.0	1.1	1.1	1.1	1.1	1.1
Magenta	1.2	1.3	1.5	1.7	1.9	2.1
Cyan	1.1	1.2	1.3	1.4	1.5	1.6

If you change the filter pack in the enlarger, you must adjust exposure time to compensate. As with negatives, multiply the exposure time by the factors shown above when adding filtration, and divide when you take filters out. In all but the most critical applications, you can effectively ignore the corrections for yellow.

Filter ring-around for reversal printing

Compare your test with this chart to identify elusive color casts, then apply one of the two recommended filtration changes to correct the color of your final print. Once you have a perfect print from one of your transparencies, you can make your own ring-around. Such a homemade chart gives you useful practical experience in filtration changes and a better grasp of the specific combination of materials that you use.

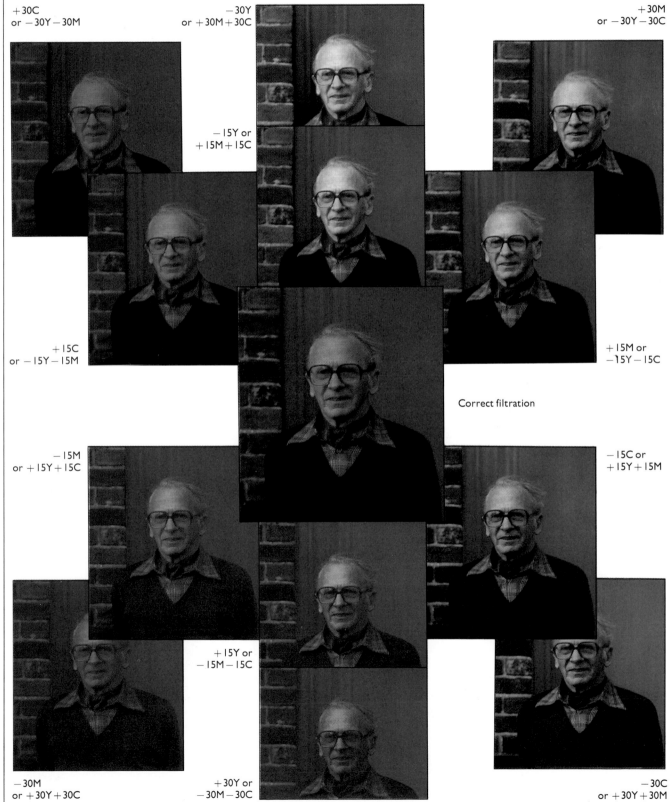

+30C
or −30Y −30M

−30Y
or +30M +30C

+30M
or −30Y −30C

−15Y or
+15M +15C

+15C
or −15Y −15M

+15M or
−15Y −15C

Correct filtration

−15M
or +15Y +15C

−15C or
+15Y +15M

+15Y or
−15M −15C

−30M
or +30Y +30C

+30Y or
−30M −30C

−30C
or +30Y +30M

Rapid printmaking

Equipment and materials are available that enable you to make color prints much more simply and quickly than by using more traditional processes. The sequences here show how to process prints from negatives or slides using Kodak's Ektaflex PCT products (right). Apart from an enlarger with a color head or filters, these products are all you need for printmaking.

The materials are quite different from those for traditional printing. Instead of color printing paper, you use Ektaflex PCT film and paper. There are two types of film, one for use with color negatives and one for slides. The process requires exposing your film onto the PCT film, from which dyes are transferred onto the paper when the emulsions are sandwiched together in the printmaker and laminated. The Ektaflex PCT activator is the only chemical needed. The solution comes already made up and is effective at any room temperature between 65°F and 80°F (18°–27°C). Ektaflex PCT paper, unlike standard color printing paper, is not light-sensitive. However, the films must be handled in total darkness or with the recommended safelight.

Simple as printing is with these products, some precautions are necessary. Wear rubber gloves and eye protection when using the activator, which is highly caustic. Make sure the printmaker is rigidly fixed to the work surface and use a level to check that it sits flat. The film-loading ramp must be dry or the film may jam. Cranking should be done smoothly or you may stripe the print. Once the film-and-paper sandwich has emerged, you can avoid dark edgemarks by putting the sandwich in a drawer or by leaving the lights off during the lamination period. Handle the laminate by its edges until dry. Never wash the prints, as this may affect the dyes.

Equipment checklist
Enlarger with color head or filters
Cardboard mask
Ektaflex printmaker(1)
Rubber gloves
Goggles or glasses
Thermometer
Timer
Storage bottle

Materials checklist
Ektaflex PCT activator (2)
Ektaflex PCT paper (3)
Ektaflex PCT negative
or reversal film (4)

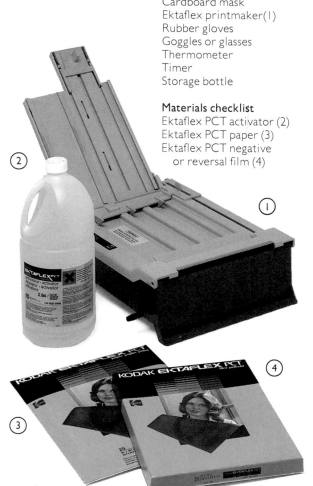

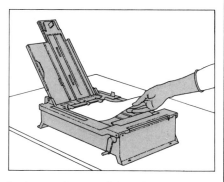
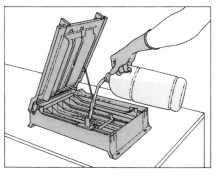

Preparing to print

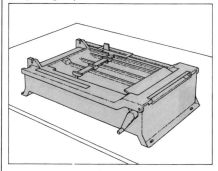

1 – Set up the Ektaflex printmaker on a firm, flat workbench or table in the darkroom. Secure the printmaker with clamps or screws (there are screw holes to facilitate this) and check that it is absolutely level.

2 – Put on rubber gloves and goggles or glasses. Carefully pour the activator solution into the printmaker tray, up to the level marked on the fill posts. Clean up spills or splashes at once with a wet cloth.

3 – Lower the top of the printmaker gently to avoid splashing. Lay a sheet of the paper, emulsion side (that is, white side) down, on the paper shelf. The left-hand edge should be under the paper-advance rake prongs.

Exposing and processing

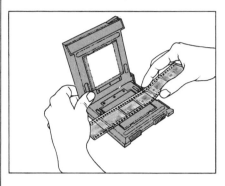

1 – Select a color negative or slide that has been exposed and developed correctly and that shows a full color and tonal range. Place it *emulsion side up* in the enlarger's negative carrier and replace the carrier in the enlarger.

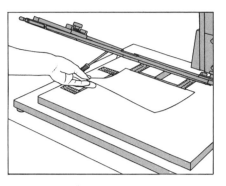

2 – Put a piece of paper of similar thickness to Ektaflex PCT film in the easel. Turn off the lights and compose and focus the image. Make fine-focus adjustments using a focus magnifier, with the lens at full aperture.

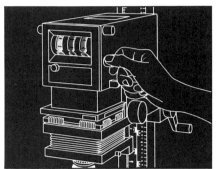

3 – Follow the instructions on the film package to determine the starting filtration and lens aperture for color negative or reversal printing. Set the filtration and exposure accordingly, and remove the dummy focusing sheet.

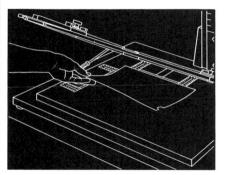

4 – In complete darkness or with the recommended safelight, place a sheet of Ektaflex PCT or reversal film in the easel. The notched edge should be on the right, with the notch toward the front of the enlarging easel.

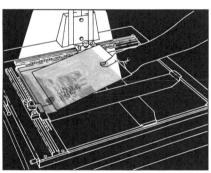

5 – Using a cardboard mask, make a series of test exposures. Begin with a five-second exposure and move the mask an inch at a time at carefully timed five-second intervals until the entire sheet of film is exposed.

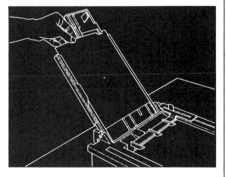

6 – Place the exposed sheet of film, still with the emulsion side up, on the printmaker's film-loading ramp. Check that the notch of the film is at the right-hand end of the top side of the printmaker's ramp.

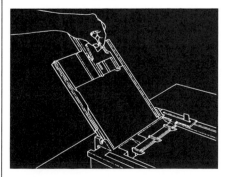

7 – Move the ramp slide steadily and smoothly downward so that the film feeds easily into the tray. When the film is inside, return the slide to its original position and start the timer to regulate soaking.

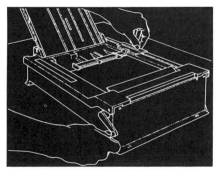

8 – Soak for 20 seconds. Just before the end of the soak time, begin cranking the film lamination rollers. Continuing to crank smoothly and steadily, slide the film-advance handle until the rollers catch the paper and film.

9 – When the film-and-paper sandwich emerges, note the time. Allow between six and 15 minutes for lamination, depending on room temperature, then gently peel the film and paper apart to yield the finished print.

Special effects in color

With the added dimension of color, you can not only expand on the techniques used to modify a monochrome print; you can also utilize darkroom manipulations that have no equivalent in black-and-white printing. For example, the image at center was made by processing a slide in negative chemicals.

A color photogram, such as the one opposite, is created by the same method as a black-and-white photogram – placing an object directly on printing paper and then exposing it. But color photograms require special care with filtration. To prevent a yellow cast from appearing, print onto color negative paper using extra yellow and a little extra magenta filtration. Or place a piece of processed, but unexposed, color negative film in the negative carrier, then expose with normal filtration.

Composite images require much experimentation before they look as good as the example at far right on the opposite page. And because color materials are quite costly, you may prefer to practice masking and dodging techniques on an image using black-and-white paper before printing in color.

If you diffuse the image from the enlarger, the results will differ according to whether you start from a negative or a transparency. Diffusing a negative spreads out the shadow areas, as shown below at left; diffusing a transparency has the opposite effect, spreading out the highlights into the shadows.

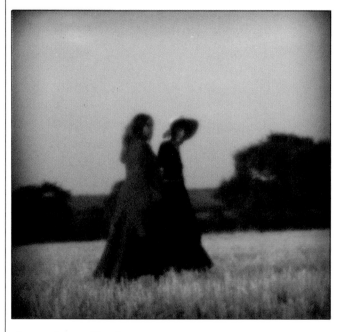

A country walk takes on softened, ghostly outlines and pastel colors in the darkroom. The photographer smeared grease onto a sheet of glass and held this beneath the enlarger lens as he exposed the negative.

Dressmaker's pins and their paper holder (right) make an attractive wheel-like photogram. Careful filtration ensured that a yellow color cast did not obscure the delicate hues of the glass pinheads.

A leafy profile (below) contrasts with a drab city backdrop in this composite image. The photographer cut out the head from black cardboard and rested the mask on the printing paper surface while exposing the cityscape. Then he replaced the mask with the sheet of cardboard from which it was cut, and printed the leaf image through the head-shaped hole.

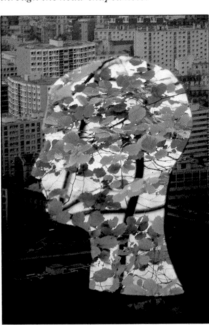

Surreal flowers (left) reach up on slender stalks. To create these colors, the photographer took an exposed slide film and developed it in chemicals designed for processing negatives. He then printed the picture onto reversal paper.

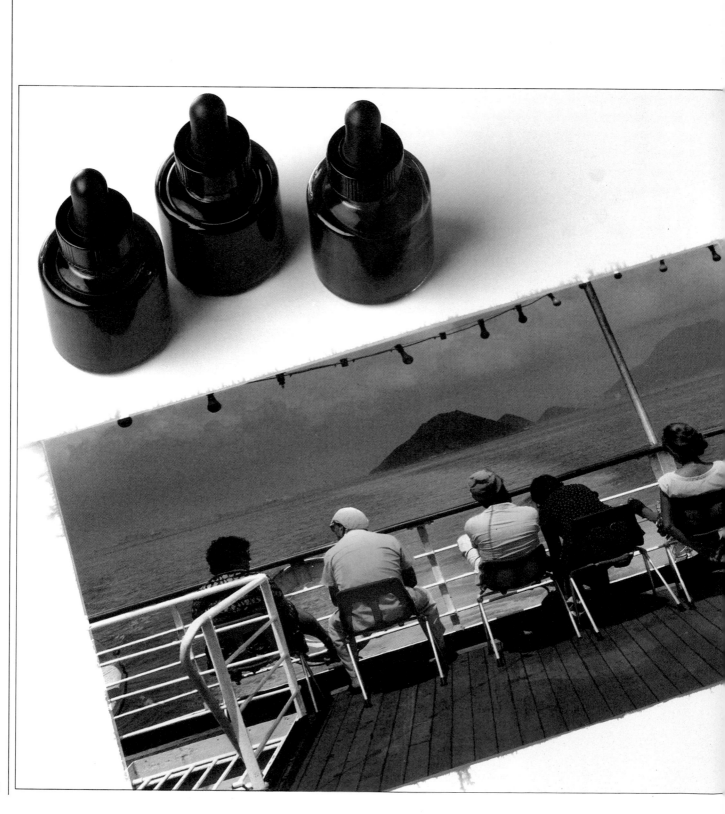

PRINT FINISHING AND DISPLAY

A row of prints hanging up to dry is a satisfying reward for an evening's work in the darkroom. But the picture-making process need not end here, any more than it ended at the moment when you released the camera shutter to take the photograph and wound on the next frame.

Outside the darkroom there are various methods you can use to alter the whole appearance of a photograph. For example, a simple two-bath toning process will transform a black-and-white print by changing it to a nostalgic sepia or a bright primary hue. Another way to add color is to tint a black-and-white print using inexpensive dyes or paints. Whereas color film copies the colors of the world in a literal way, hand-coloring enables you to create more personal images. The photographer who took the picture at left successfully used this technique to suggest the half-remembered pleasures of a cruise vacation.

After printing you can also put important finishing touches on a picture. With a brush and some retouching dyes, you can remove the small but disfiguring marks that a dusty negative leaves on a print. And a carefully trimmed and mounted print hanging on a wall looks far more impressive than the same picture lying casually on a table top or tucked into an album.

Hand-tinting adds candy-colored hues to a black-and-white print, and lends the image a life and charm that an ordinary color print would never match. The photographer used water-based dyes to spread the washes of color across the picture.

Toning black-and-white prints

Toning is a simple yet effective way to improve a print, or to add atmosphere. For example, sepia-toning lends softness and warmth to portraits and gives traditional subjects a nostalgic feeling. A blue toner can be used to suggest coldness in snow or in a seascape. Alternatively, you might tone part of an image to strengthen the composition, or combine two or more tones in a single print, as in the picture on the opposite page.

Any technique that alters the finished image should be used with discrimination, and this is certainly true of toning. Think carefully whether the treatment really suits the subject. Consider, too, the quality of the print. You can hardly improve on a first-class print that has rich blacks, pure whites and a full range of gray tones. On the other hand, you cannot expect to save a weak, flat print simply by a change of color. For the best results, you should choose a correctly exposed and developed print.

The toning process works either by changing the silver in the image into a chemical salt, or by coating the silver with gold. Toning acts only on the areas where an image exists. The dark areas give the deepest tones, while the lightest areas are affected only slightly. Commercial toners produce varying effects, depending on the type of chemicals in the toning solution. The grade, tone and finish of the printing paper you use also affect the result. Always follow the directions precisely. Some toners alter image density and contrast, and you may need to make a special print for toning, adjusting exposure during enlarging to compensate.

If you are going to tone a print you have just processed, make sure you fix and wash it thoroughly, or toning may be blotchy and uneven. If you start with a dry print, presoak it well. Judging how long to tone a print may be difficult at first. Comparison with an identical wet black-and-white print will help you assess the depth of tone. Combination toning is no more difficult than single toning, although the process obviously takes longer. If you apply toners with a paintbrush, varnish the metal ferrule so that it does not contaminate the toning solutions and cause discoloration or staining.

Single-toning a print

The sequence starting at right shows the technique for sepia-toning a print using a two-solution toner kit. A number of different kits are available, some with a combined solution for bleaching and toning in one stage. Sepia toners may be sulfide- or selenium-based. Most toners help prolong the life of the print as well as change the color of the image. You can buy toners in other colors to create shades of blue, green, red and yellow. Alternatively, you can buy chemicals to make up your own toners from some photographic dealers. Toning solutions tend to react to metal, so always use plastic trays and filtered water if there are impurities.

1 – Wearing rubber gloves, make up the bleach and toning solutions according to the manufacturer's instructions. Pour each solution into a plastic tray.

2 – Immerse a black-and-white print in a water bath for the recommended time. Use a properly exposed and developed print with good contrast and density.

3 – Slide the presoaked print into the tray of bleach. Gently rock the tray back and forth until the black disappears and only a faint, buff-colored image remains.

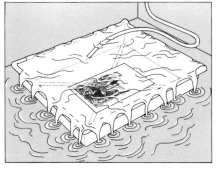

4 – Rinse the print thoroughly under running water for two to five minutes, until no trace of yellow bleach remains. Immerse the washed print in the toner.

5 – Rock the tray as before. When the print has stopped changing color, or the tone looks right, take out the print and wash and dry it in the normal way.

Combination toning

The black-and-white print at right was given two toning treatments in different colors to create the new version below. One method of combination toning is to mask off selected areas of the print at each toning stage. For this method, you need a toner kit with a separate bleach solution and extra toners in different colors. After bleaching, washing and drying, paint rubber cement over the areas to be masked. Immerse the print in the first toner and dry it. Rub off all or part of the rubber cement mask, depending on how many toners you are using. Mask off the toned area and repeat the process. For smaller areas, apply toners with a brush.

Spotting and hand-coloring

With a steady hand and a little patience, you can use basic painting methods to correct or creatively manipulate the appearance of a monochrome print. You may simply want to cover up dust specks, as described below, or paint out small skin blemishes in a portrait. More ambitiously, you might try hand-coloring a print to impart a period flavor (as in the examples opposite) or to control hues in a way that is not possible with color printing.

The best subjects to hand-color are those with predominantly light tones. Make several prints from each negative as a safeguard against mistakes. For optimum results, underexpose slightly on fiber-based mat or semimat paper, and then sepia-tone the prints using the method already described.

You will need several brushes, with tips ranging from broad (6) to very fine (00), and a palette cup to mix the dyes. Oil-based dyes or artists' oil colors give softer effects than do water-based dyes, and are easier to remove from the print surface if wrongly applied. However, water-based dyes are simpler to work with.

If you wish to color a large area with a water-based dye, you must first soak the print for several minutes in water containing a few drops of wetting agent. Then remove excess water with a sponge and tape the print down to your work surface to prevent curling. For the very broadest patches of color, apply the dye with a swab of cotton. Then proceed to the brushwork, choosing the tip size according to the size of the area you are painting. On a dry print, you can mask off surrounding areas with rubber cement which you later peel off. Paint small details last, using one application of strong dye on a very fine brush. Let the finished print dry thoroughly before you handle it.

Spotting prints
However carefully you handle your negatives prior to enlargement, you will occasionally make a print that is marred by small white specks, caused by dust on the negative. You can remove such marks by retouching, or spotting, the print using a spotting dye and a fine brush, as explained in the step-by-step sequence of pictures here. It is normally less time-consuming to spot a print than to make a new one from the negative.

Color dyes are available for retouching color prints, but they are difficult to use. It is easier to spot color prints in shades of gray, by the method described here.

Equipment checklist
Retouching brush or fine-tipped sable paintbrush (0, 00 or 000)
White plate or saucer
Cotton swab or paper tissue
Blotting paper

Materials checklist
Bottle of spotting dye

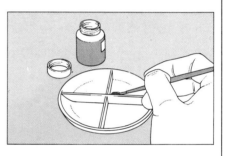

1 – Transfer a little dye to a plate or saucer, using a moistened brush, then add drops of water to dilute the dye until it is slightly lighter than the image density you have to match: you will find that the dye darkens slightly after you apply it.

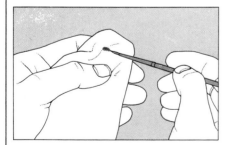

2 – Dry the brush on a piece of tissue. Pick up a little of the diluted dye on the brush tip; roll it back and forth on the plate to remove excess dye and to shape the tip to a fine point. If the brush tip is still too wet, roll it on a piece of blotting paper to absorb the excess moisture.

3 – Gently touch the brush tip on the spot you want to disguise. Repeat, keeping the dots within the area of the spot, until it blends with the surrounding tone. As you work, the dye on the brush will become weaker, so with each brushload move progressively from the darker to the lighter areas.

4 – If your brush releases a large drop instead of a dot, wipe off the excess dye from the print quickly with a tissue or swab of cotton. Do not reapply dye to the same spot until it is completely dry. After you have finished, rinse the brush and allow it to air-dry before putting it away.

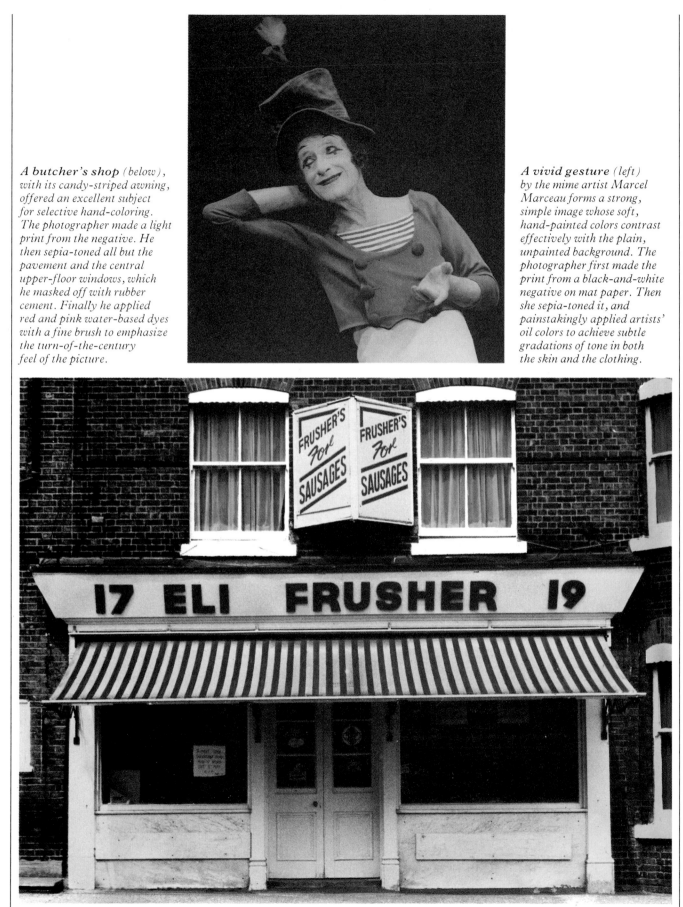

A butcher's shop (below), with its candy-striped awning, offered an excellent subject for selective hand-coloring. The photographer made a light print from the negative. He then sepia-toned all but the pavement and the central upper-floor windows, which he masked off with rubber cement. Finally he applied red and pink water-based dyes with a fine brush to emphasize the turn-of-the-century feel of the picture.

A vivid gesture (left) by the mime artist Marcel Marceau forms a strong, simple image whose soft, hand-painted colors contrast effectively with the plain, unpainted background. The photographer first made the print from a black-and-white negative on mat paper. Then she sepia-toned it, and painstakingly applied artists' oil colors to achieve subtle gradations of tone in both the skin and the clothing.

Trimming and mounting

If you have gone to the trouble of making a beautiful print, there is little sense in hiding it away unseen in a envelope. Careful mounting and display, as demonstrated opposite, not only show your photographs to the very best advantage, but also protect your prints from damage.

The simplest way to mount a print is to use adhesive to fix the picture permanently onto a piece of mounting board. You will need to buy an adhesive that is specially designed for photographic use – other types may be absorbed into the print, causing the image to fade. Liquid adhesives, such as Kodak rapid mounting cement, are cheap and easy to use, but be sure to follow manufacturer's instructions carefully, or the print may peel up from the mount. Liquid adhesive leaves marks on the mounting board

if it oozes outside the area covered by the print. So you may prefer instead to use double-sided adhesive material, which you can buy in sheets or rolls. Follow the instructions below when fixing the print to the mount.

Mounts can be more imaginative than just broad white borders around the image. Consider using mounting board in a color that complements the hues of your print. Or try making a window mount, as explained at the bottom of the page. This shows off your picture behind a recessed cardboard cutout, giving the image a sense of depth. You may even choose to eliminate the borders altogether and trim the mount flush with the edges of the image area; styrofoam plastic boards simplify the process of print mounting in this way.

Simple mounting

 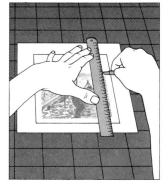 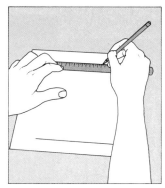

I – Peel the backing paper off the adhesive sheet and place the print with the picture facing upward on the exposed adhesive surface.

2 – Trim the print and the excess adhesive sheet to the size that you want, then turn the print over and peel off the protective backing.

3 – Mark the board so that you can position the print squarely. You may want a wider border at bottom than on the other sides.

4 – Carefully place the print onto the mount; be sure that it is in the right position before pressing it down firmly.

Window mounting

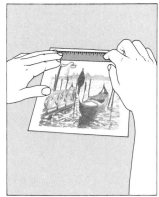 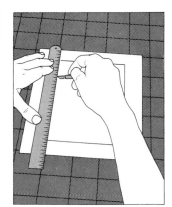

I – Measure the image area of the print and mark where you want the window on one of two sheets of board, leaving even borders all around.

2 – Cut out the window area using a sharp craft knife and a steel rule, then place the two sheets of cardboard on top of each other.

3 – Mark the corners of the window area on the lower sheet of board, and tape the print in position on top of the four corner marks.

4 – Use double-sided tape to fix the boards together so that the print appears framed by the window in the top piece of mounting board.

A block mount (below) is a more
modern approach. Here the picture
is mounted on a styrofoam plastic
block, a half-inch (12mm) thick and
trimmed flush with the edges of the
print for dramatic effect.

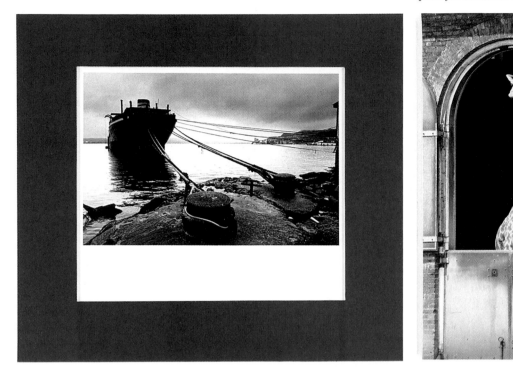

A window mount (above) is a
traditional way of enhancing the
appearance of a print. Here the
photographer has adapted the tradition
in an original way by cutting a big
enough window to show the print's
broad white bottom border, which
leads the eye into the picture.

Multiple images (right) can be
unified by a well-chosen mount and
frame. These instant prints of a
railway yard look interesting enough
individually; framed together, they
form an elegant and eye-catching
picture essay.

Glossary

Acetate
A flammable material used as a base for photographic emulsion. In dyed form, acetate is used to make color filters.

Aperture
An opening in a camera or enlarger lens that regulates the amount of light that is allowed to pass through.

Bleach
A chemical bath to convert the black metallic silver that forms a photographic image into a compound such as a silver halide, which can then be dissolved or dyed. Bleach is used in toning and in many color processes.

Blix (bleach-fix)
A combined bleach and fixer bath used to shorten color processing.

Burning-in (printing-in)
A technique used in printing photographs whereby selected areas of an image are given more exposure than the rest. Other areas are shaded from the light during this time.

Cassette
A metal or plastic film container that allows a tongue of film to be threaded onto a rotating spool inside the camera. After exposure the film is wound back into the cassette before being unloaded.

Changing bag
A bag made of opaque material and having elasticized sleeves to allow the handling of light-sensitive materials outside the darkroom.

Color cast
An overall tinge of a particular color in a print or transparency.

Color developer
A chemical that develops both the silver image and the color dyes in color film.

Color head
A device on an enlarger that contains adjustable built-in filters (yellow, cyan and magenta) for color printing.

Color paper
A light-sensitive material on a paper base for making color prints from color negatives or transparencies. The paper is coated with three emulsion layers, which respond to red, green and blue light, forming cyan, magenta and yellow dye, respectively.

Color reversal
A type of color film, printing paper or process in which a positive color image (usually in the form of a transparency mounted as a slide) is produced from a scene or positive original without requiring an intermediate negative stage.

Combination printing
A general term describing a number of photographic techniques in which more than one negative or transparency is printed onto one sheet of printing paper to make a composite image.

Complementary colors
Any two colors that produce an achromatic shade (white, gray or black) when mixed. Complementary color pairs are important in color films and printing processes. The pairs used are red-cyan, green-magenta and blue-yellow.

Condenser
A lens or lens system used in an enlarger or slide projector to concentrate light from the lamp source and focus it evenly on the negative or slide.

Contact sheet
A sheet of negative-sized photographs made simply by placing the printing paper in direct contact with the negatives during exposure.

Contrast
The difference in brightness between the lightest and darkest parts of a photographic subject, negative, print or slide. Contrast is affected by the subject brightness, lighting, film type, degree of development, the grade and surface of the printing paper, and the type of enlarger used.

Couplers
The chemicals used in color film emulsions or in the developers that "couple" with exposed silver halides to release dyes that form the color image.

Cropping
Trimming or masking an image along one or more of its edges to eliminate unwanted parts.

Developer
A solution containing a number of chemicals that will convert a latent image on an exposed photographic material to a visible image.

Developing tank
A light-tight container, made of plastic or steel, in which film is developed. The exposed film is loaded into the tank in complete darkness, and temperature-controlled chemicals are added at precisely timed intervals to make the image visible and stable.

Dodging (shading)
Means of reducing exposure in selected areas during printing by holding a solid object between the lens and the light-sensitive paper. By moving the object, abrupt changes in tone can be avoided.

Drying marks
Blemishes on a photographic image caused by uneven drying. Such marks can be prevented by adding a wetting agent to the final rinse or by evenly sponging all the droplets of water off the surface.

Emulsion
The light-sensitive layer of film or printing paper. Conventional photographic emulsion consists of very fine silver halide crystals suspended in gelatin, which blacken when exposed to light. The emulsion of color film contains dye-forming chemicals as well.

Enlarger
An apparatus that makes enlarged prints by projecting and focusing an image from a negative or transparency onto light-sensitive paper, which must then be processed to reveal the final print.

Enlarger head
The part of an enlarger that contains the light source, the negative carrier and the lens. An enlarger head also houses a filter drawer or a built-in filtration system.

Enlarging easel (masking frame)
A board used with an enlarger for positioning printing paper and keeping it flat and still during exposure.

Exposure
The amount of light that passes through a lens (in either a camera or an enlarger) onto a light-sensitive material (film or photographic paper) to form an image. In the camera, too much light causes over-exposure – this makes negative film look too dark and reversal film look too light. Underexposure (too little light) has the reverse effect. In enlarging, overexposure makes a print from a negative too dark and a print from a slide too light. Underexposure has the reverse effect.

F numbers
Numbers on a camera's or enlarger's lens barrel, indicating a scale of aperture settings. Each setting progressively doubles or halves the amount of light reaching the film or paper.

Fiber-based paper see PHOTOGRAPHIC PAPER

Film
Light-sensitive material in the form of an emulsion coating a flexible base of acetate or plastic. Black-and-white films have one emulsion layer, color films have three layers sandwiched together. Color negative film is used to produce prints; it records the colors of the subject in complementaries that are subsequently reversed again in the printing process to

produce the correct colors. Color reversal film produces a direct positive (usually in the form of a transparency mounted as a slide) by reversing the negative image during processing.

Film speed
A film's sensitivity to light, which is rated numerically so that it can be matched to the camera's exposure controls. The two most commonly used scales, ASA (American Standards Association) and DIN (Deutsche Industrie Norm), are now superseded by the new system known as ISO (International Standards Organization), which amalgamates the ASA and DIN ratings.

Filter
A translucent material, such as glass, acetate or gelatin, used with a camera or enlarger to modify the light passing through the lens and so to control the appearance of the image, for example by altering its color. The assembly of filters used in an enlarger for color printing is known as a filter pack, and normally consists of any two of the three subtractive primaries (yellow, magenta, cyan) in the appropriate strengths.

Filter drawer
A part of an enlarger head that holds the filters used in color printing.

Filtration
In color printing, the use of filters to control the colors of the enlarged image and thus of the final print.

Fixer
A chemical bath used to make a photographic image stable after it has been developed. The fixer stabilizes the emulsion by converting the undeveloped silver halides into water-soluble compounds, which can then be dissolved away.

Fluorescent light
Light from a fluorescent lamp, which consists of a tube coated internally with a fluorescent material such as phosphor and containing mercury vapor that produces ultraviolet radiation during an electric discharge. The phosphor absorbs the ultraviolet radiation and emits visible light. Care must be taken in any darkroom where a fluorescent light is used, as it can take up to five minutes for the radiation to subside, even after the light has been turned off. Avoid fluorescent lights near a display of prints.

Focal length
The distance, usually given in millimeters, between the optical center of a lens and the point at which rays of light from objects at infinity are brought into focus.

Focusing magnifier
A device, employing a low-power microscope and mirror, used for checking the focus of an enlarging lens during printing.

Fogging
A veil of silver in a negative or print that is not part of the photographic image. Fogging is often accidental and can be caused by light entering the camera, film cassette or darkroom and partially exposing the film or paper, by faulty processing solutions such as an overactive developer or a weak fixer, or by improper storage of the unexposed material. Intentional fogging, however, is a crucial stage in color reversal processing.

Format
The size or shape of a negative, transparency or print.

Graduate
A calibrated glass, plastic or steel container used for measuring liquids, for example photographic chemicals, by volume.

Infrared
Electromagnetic radiation of a wavelength greater than that of red light. Infrared radiation can be recorded photographically on specially sensitized film, in either color or black-and-white.

Internegative film
A color film designed to produce copy negatives from either color slides or color prints. It is specially designed to avoid the contrast changes that are usually inherent in the copying technique. Color internegative film is often used to produce a negative when color prints are desired from a transparency.

Lamphouse
Part of an enlarger or projector containing the lamp or light source.

Latent image
Invisible image recorded on photographic emulsion as a result of exposure to light. A developer converts the latent image into a visible one.

Loupe
A simple lens that is held to the eye to provide a magnified view of a negative or transparency.

Masking
The act of blocking out light from selected areas of an image for various purposes; for example, to cover the edges of a piece of printing paper during exposure to produce white borders.

Masking frame see ENLARGING EASEL

Negative
A developed photographic image in which light tones are recorded as dark and dark ones as light. In color negatives, each color of the original subject is represented by its complementary. Usually, a negative is made up on a transparent base so that light can be beamed through it onto light-sensitive printing paper to form a positive image.

Negative carrier
A device that holds a negative or transparency flat in an enlarger between the light source and the lens.

Photogram
A photographic image produced without a camera by arranging objects on the surface of photographic paper or in the negative carrier of an enlarger so that they cast a shadow on the paper as it is being exposed.

Photographic paper (printing paper)
Paper coated with a light-sensitive emulsion, used for making photographic prints. When a negative or slide is projected onto printing paper a latent image forms, and this is revealed by processing. Printing paper may be fiber-based or resin-coated (RC); the resin-coated papers offer speedier processing because they are water-repellent. Papers come in grades according to their contrast range.

Positive
A photographic image that corresponds in tonal values to the original subject.

Primary additive colors
Blue, green and red. Lights of these colors can be mixed together to produce white light or light of any other color.

Print
A photographic image produced by the action of light (usually passed through a negative or transparency) on paper coated with a light-sensitive emulsion.

Printing-in see BURNING-IN

Printing paper see PHOTOGRAPHIC PAPER

Processing
The sequence of activities (usually developing, stopping, fixing, washing and drying) that will convert a latent image on film or photographic paper into a visible, stable image.

Processing drum (processing tube)
A light-tight container in which photographic paper is processed in daylight. The drum is used particularly for color print processing, in which temperature, solution consistency, timing and agitation need careful control.

Push-processing
Increasing development time or temperature during processing, usually to compensate for underexposure in the camera or to increase contrast. Push-processing is often used after uprating the film to cope with dim lighting. See UPRATING

Reel
The inner core of a developing tank, used to hold film in a spiral to prevent one layer of film from touching another during processing. Some reels are adjustable to fit different film formats.

Resin-coated (RC) paper see PHOTOGRAPHIC PAPER

Safelight
A special darkroom lamp whose light is of a color and intensity that will not affect light-sensitive photographic materials. Not all such materials can be handled under a safelight, and some require a type designed specifically for them.

Sandwiching
Combining two or more negatives or slides to produce a composite image, either on one sheet of printing paper or on a slide-projection screen.

Shading see DODGING

Silver halide
A light-sensitive compound of silver with a halogen such as bromine, chlorine or iodine. Silver halides are the main constituents in photographic emulsion. The latent image produced on these halides by the action of light is converted to metallic silver by developers.

Spotting
Retouching a print or negative to remove spots and blemishes.

Stabilization
Black-and-white processing in a single solution when speed is more important than stability.

Stabilizer
A processing solution used in color processing to make the dyes produced by development more stable.

Stop bath
A weak acidic solution used in processing as an intermediate bath between the developer and the fixer. The stop bath halts development and at the same time neutralizes the alkaline developer, thus preventing it from lowering the acidity of the fixer.

Subtractive color printing
A means of producing a color image by blocking (or subtracting) appropriate amounts of unwanted colored light from white light. Most photographic processes use dyes or filters of three colors known as the subtractive primaries – cyan, magenta and yellow.

Test-strip
A strip of printing paper that is given a range of exposures or filtrations across its length as a test for the correct image density or color.

Timer
A clock designed to time exposure or stages in processing. An interval timer gives an audible signal after a preset period has elapsed. Some timers can be linked to the enlarger to turn off the light source automatically.

Toner
Chemical used to add a degree of color to a black-and-white print or positive transparency. A toner can also increase stability by replacing the silver in the image with a more stable metal.

Transparency
A positive image viewed by transmitted rather than reflected light. When mounted in a metal, plastic or cardboard mount, a transparency is called a slide.

Ultraviolet
Electromagnetic radiation of wavelengths shorter than those of violet light. Ultraviolet (UV) radiation is invisible to the human eye, but affects most photographic materials unless removed by a filter.

Uprating
Setting a film speed on the camera higher than that at which the film was designed to be used. Effectively, this means underexposing to cope with dim light; an appropriate compensation is then made for the underexposure by increasing, or "pushing," the development time.

Variable-contrast paper
Black-and-white photographic paper that has variable contrast. Adding yellow filtration to the enlarger filter pack reduces the contrast of the print, and adding violet filtration adds to the contrast.

Vignette
Photograph printed in such a way that the image fades gradually into a featureless black or white border area, produced by using a suitably shaped mask to dodge or burn-in the whole of the central area.

Wetting agent
A chemical that lowers the surface tension of a solution, allowing it to spread evenly and quickly over a surface. During processing, a wetting agent can be added to the developer to prevent the formation of air bubbles on the emulsion, and in the final rinse to promote even drying.

Index

Acknowledgments

Picture Credits
Abbreviations used are: t top; c center; b bottom; l left; r right.

Cover: Dan Morrill/Click/Chicago

Title William Meyer/Click/Chicago. **7** Nancy Brown/Image Bank. **8** Al Satterwhite/Image Bank. **8-9** Helena Zakrzewska-Rucinska. **10** Julie Harvey. **11** Tim Stephens. **12-13** Nick Scott. **13** Sue Adler. **14-15** Sanders Nicolson. **16-17** Laurie Lewis. **19** Richard & M. Magruder/Image Bank. **30-31** Fay Godwin. **44** Richard Platt. **46** Nick Meers. **48-49** Clive Boursnell. **50** Timothy Woodcock. **53** t Laszlo Willinger/Kobal Collection, b John Freeman. **55** All Clive Boursnell. **56-57** John Hedgecoe. **58** Alastair Black. **59** Gene Nocon. **60** l Timothy Woodcock, r John Freeman. **61** Nick Scott. **86** Tim Stephens. **87** Tim Stephens. **90** Clive Boursnell. **90-91** De Lory. **91** t Tim Stephens, b Fotogram. **92-93** Helena Zakrzewska-Rucinska. **95** John Hedgecoe. **97** t Amanda Currey, b Helena Zakrzewska-Rucinska.

Additional commissioned photography by Michael Busselle, John Freeman, Laurie Lewis, John Miller, Nick Scott, Tim Stephens, Frank Thomas, Timothy Woodcock.

Acknowledgments F.E. Burman, Cowling & Wilcox, Ilford UK, Johnsons of Hendon, Keith Johnson Photographic, Paterson, Pelling & Cross, Frank Thomas.

Artists David Ashby, Edwina Keene, Aziz Khan, Sandra Pond, Andrew Popkiewicz.

Retouching Roy Flooks

Kodak, Ektachrome, Kodachrome and Kodacolor are trademarks